# Color Anal

## Investigating Light and Color

## GEMS® Teacher's Guide for Grades 5–8
### (can be adapted for grade 9)

*by*
**John Erickson** and **Carolyn Willard**

## Skills
Observing • Comparing • Describing • Classifying • Inferring
Predicting • Recording Data • Drawing Conclusions

## Concepts
Properties of Light and Color • Color Filters and Diffraction Gratings

## Themes
Systems and Interactions • Energy • Matter • Stability • Scale

## Mathematics Strands
Logic and Language • Pattern

## Nature of Science and Mathematics
Scientific Community • Interdisciplinary • Cooperative Efforts
Creativity and Constraints • Theory-Based and Testable
Real-Life Applications • Science and Technology
Changing Nature of Facts and Theories

## Time
Five 45–60 minute class sessions

**Great Explorations in Math and Science**
**Lawrence Hall of Science**
**University of California at Berkeley**

Lawrence Hall of Science,
University of California,
Berkeley, CA 94720-5200

**Director:** Elizabeth K. Stage

**Cover Design, Internal Design, and Illustrations:** Lisa Klofkorn
**Inside Front Cover Illustrations:** John Erickson
**Photography:** Richard Hoyt

**Director:** Jacqueline Barber
**Associate Director:** Kimi Hosoume
**Associate Director:** Lincoln Bergman
**Mathematics Curriculum Specialist:** Jaine Kopp
**GEMS Network Director:** Carolyn Willard
**GEMS Workshop Coordinator:** Laura Tucker
**Staff Development Specialists:** Lynn Barakos, Katharine Barrett, Kevin Beals, Ellen Blinderman, Gigi Dornfest, John Erickson, Stan Fukunaga, Karen Ostlund
**Distribution Coordinator:** Karen Milligan
**Workshop Administrator:** Terry Cort
**Trial Test and Materials Manager:** Cheryl Webb
**Financial Assistant:** Vivian Kinkead
**Distribution Representative:** Fred Khorshidi
**Director of Marketing and Promotion:** Steven Dunphy
**Principal Editor:** Nicole Parizeau
**Editor:** Florence Stone

**Principal Publications Coordinator:** Kay Fairwell
**Art Director:** Lisa Haderlie Baker
**Senior Artists:** Carol Bevilacqua, Lisa Klofkorn
**Staff Assistants:** Rachel Abramson, Yvette Mauricia, Shuang Pan
**Contributing Authors:** Jacqueline Barber, Katharine Barrett, Kevin Beals, Lincoln Bergman, Susan Brady, Beverly Braxton, Mary Connolly, Kevin Cuff, Linda De Lucchi, Gigi Dornfest, Jean C. Echols, John Erickson, David Glaser, Philip Gonsalves, Jan M. Goodman, Alan Gould, Catherine Halversen, Kimi Hosoume, Susan Jagoda, Jaine Kopp, Linda Lipner, Larry Malone, Rick MacPherson, Stephen Pompea, Nicole Parizeau, Cary I. Sneider, Craig Strang, Debra Sutter, Herbert Thier, Jennifer Meux White, Carolyn Willard

original 1989 edition
authored by
**Cary I. Sneider**
**Alan Gould**
**Cheryll Hawthorne**

Initial support for the origination and publication of the GEMS series was provided by the A.W. Mellon Foundation and the Carnegie Corporation of New York. Under a grant from the National Science Foundation, GEMS Leaders Workshops were held across the United States. GEMS has also received support from: the Employees Community Fund of Boeing California and the Boeing Corporation; the people at Chevron USA; the Crail-Johnson Foundation; the Hewlett Packard Company; the William K. Holt Foundation; Join Hands, the Health and Safety Educational Alliance; the McConnell Foundation; the McDonnell-Douglas Foundation and the McDonnell-Douglas Employee's Community Fund; the Microscopy Society of America (MSA); the NASA Office of Space Science Sun-Earth Connection Education Forum; the Shell Oil Company Foundation; and the University of California Office of the President. GEMS also gratefully acknowledges the early contribution of word-processing equipment from Apple Computer, Inc. This support does not imply responsibility for statements or views expressed in publications of the GEMS program. For further information on GEMS leadership opportunities, or to receive a publications catalog and the GEMS *Network News,* please contact GEMS. We also welcome letters to the GEMS *Network News.*

Inside back cover photo shows Nebula in Serpens (Eagle).
© 1965 by California Institute of Technology. Reprinted with permission.

ISBN-13: 978-0-924886-89-8

ISBN-10: 0-924886-89-7

Printed on recycled paper with soy-based inks.

### Library of Congress Cataloging-in-Publication Data

Erickson, John, 1961-
  Color analyzers : investigating light and color : GEMS teacher's guide for grades 5/8 (can be adapted for grade 9) / by John Erickson and Carolyn Willard.-- [New GEMS ed.].
    p. cm.
  Rev. ed. of: Color analyzers / Cary I. Sneider, Alan Gould, Cheryll Hawthorne. 1989.
  Summary: "Presents a series of investigations that effectively challenge commonly held misconceptions and lead to a deeper understanding of the nature of light and color, and the color spectrum"--Provided by publisher.
  Includes bibliographical references.
  ISBN-13: 978-0-924886-89-8 (pbk.)
  ISBN-10: 0-924886-89-7 (pbk.)
  1. Color--Study and teaching (Elementary)--Activity programs.
2. Light--Study and teaching (Elementary)--Activity programs.
I. Willard, Carolyn, 1947- II. Sneider, Cary Ivan. Color analyzers.
III. GEMS (Project) IV. Title.
  QC496.E75 2005
  535.6--dc22

2005003999

# ACKNOWLEDGMENTS

The classroom activities in the *Color Analyzers* unit were first used in a planetarium program called "Colors In Space," developed by Michael Askins, with help from Alan Friedman, Alan Gould, and other staff members of the Astronomy and Physics Education Department at the Lawrence Hall of Science. The "secret messages" in this guide were created by John Erickson. The activities in the original guide were further developed and pilot tested in classrooms by Cheryll Hawthorne and Cary Sneider. Special thanks to Sue Kalmus, a teacher who tested the final version of the first GEMS guide's activities, and to her students in Richmond, California, who contributed the student worksheets.

For her suggestions and corrections regarding information on the human visual system in earlier revisions of this guide, we thank Karen de Valois. Alan Gould, John Erickson, and Carolyn Willard also made important contributions to earlier revised editions, as did Edna de Vore who provided detailed suggestions on different ways to project a spectrum in the classroom.

The authors of this New GEMS edition are especially grateful to Kathy Freeburg and her class at Rosa Parks Elementary School in Berkeley, California, for their assistance and participation in the pilot testing of revised and new activities in 2004.

We very much appreciate the scientific review of this New GEMS edition by physicist Bruce Birkett, especially his suggestions for improvements in several activities and his substantial revision of the "Background for the Teacher" section. This edition also benefited from the critical input of Jacqueline Barber, Kevin Beals, Lincoln Bergman, Steven Dunphy, and Nicole Parizeau. ■

# CONTENTS

# TIME FRAME

**B**ased on classroom testing, the following are guidelines to help give you a sense of how long the activities may take. The sessions may take less or more time with your class, depending on students' prior knowledge, their skills and abilities, the length of your class periods, your teaching style, and other factors. Try to build flexibility into your schedule so that you can extend the number of class sessions if necessary. **Please note:** the teacher preparation time in this unit is minimal, *except* in Activity 1 where one to two hours is needed for making the color analyzers.

The quantities below are based on a class size of 32 students. You may, of course, require different amounts for smaller or larger classes. This list gives you a concise "shopping list" for the entire unit. Please refer to the "What You Need" and "Getting Ready" sections for each individual activity, which contain more specific information about the materials needed for the class and for each team of students.

Options for gathering your classroom materials for this unit:

- Some teachers prefer to gather materials needed to teach a GEMS unit themselves at local stores.

- Others prefer to purchase a ready-made GEMS Kit®.

For more information on GEMS Kits, visit the web at lhsgems.org/gemskits.html or contact GEMS.

## Nonconsumables

❑ a class set of color analyzers, made from the following items (see "Getting Ready" #1 on page 8):
    __ about 35  3" x 5" index cards
    __  1  6" x 6" sheet of red filter gel
    __  1  6" x 6" sheet of green filter gel
    __  1  6" x 6" sheet of diffraction grating material
    __  (optional) 1 sheet (about 8 $\frac{1}{2}$" x 11") of clear acetate to cover the diffraction grating
❑ 1 additional 6" x 6" sheet of diffraction grating material—this sheet is left whole to cover the lens at the top of the overhead projector (see "Getting Ready" #2 on page 38)
❑ 1 lightbulb (60–100 watts)
❑ 1 lamp (without a shade)
❑ an extension cord, if necessary
❑ 2 or more other light sources such as fluorescent, neon bulbs, or sunlight (see "Getting Ready" #6 on page 10)
❑ the front cover of this guide
❑ the students' writing assignment from Activity 1 (explaining their initial ideas about light and color)
❑ (optional) 1 pair of thin rubber or cotton gloves (for handling diffraction grating)

## Consumables

❏ 32 copies of the **Color Analyzers: Light Through a Diffraction Grating** student sheet (page 18)
❏ 8 copies each of the five secret message student sheets (pages 31–35)

## General Supplies

❏ 1 pair of scissors
❏ 1 roll of clear tape
❏ masking tape
❏ 6 large pieces of paper (for signs)
❏ 1 box of colored chalk or a large piece of paper and colored markers
❏ paper to help darken the classroom
❏ 8–16 sets of crayons, colored pencils, or felt-tipped markers with the following colors: red, orange, yellow, green, blue, purple
❏ many pieces of white unlined paper (scratch paper is fine)—on which students will write and on which both you★ and the students will draw secret messages
❏ an overhead projector
❏ 2 file folders
❏ 1 piece each of red and green construction paper, each at least 3" square
❏ colored markers and a white board or crayons and a large piece of white paper
❏ *(optional)* 1 paper cutter
❏ *(optional)* 1 single-hole paper punch

★If you prefer to create your demonstration messages for Activity 2 on the overhead projector or on a whiteboard instead of paper, you'll need the appropriate colored markers.

# INTRODUCTION

**W**hy does an apple look red? That is the question!

Light and color are key science topics. An accurate understanding of light and color occupies an essential place in science standards at every level. These important physical science concepts also open up deeper student understanding in many fields, from microscopy to astronomy!

But without targeted instruction, people have a number of misconceptions about light and its role in vision, color, and related phenomena. A careful study of fifth grade students, for example, found that almost all shared mistaken ideas. The study found that, when teachers used conventional textbook-based methods of instruction, only a few students were successful in changing these misconceptions. In contrast, most students acquired more accurate understandings when teachers used activity-based, experiential materials specifically designed to help students overcome major misconceptions, similar to those in this GEMS unit (*Children's Conceptions of Light and Color*, Anderson and Smith, Michigan State University, 1983).

This New GEMS *Color Analyzers* unit engages your students in fascinating investigations that effectively challenge commonly held misconceptions and lead to a fuller understanding of the nature of light and color. Some of the activities use a simple-to-make instrument called a color analyzer—a card with three holes covered by colored filters and a special kind of plastic called a diffraction grating. In the activities, students use the color analyzer to observe phenomena that are normally hidden from view, work toward explaining what they see in their own words, and refine their explanations through group discussion and "reflection."

*Please see the "Background for the Teacher" section on page 52 for more research on common student conceptions about light and color and how students' ideas differ from those of scientists.*

*Making a class set of color analyzers is the only major preparation required for these activities. It takes one or two hours and needs to be done only once. The color analyzers are used over and over again throughout the activities and can be reused from year to year. Details on materials and construction of the color analyzers are in Activity 1.*

# Color Analyzers
## and
## National Content Standards

The science content in this unit solidly aligns with the *National Science Education Standards, Benchmarks for Science Literacy*, state science standards, and district frameworks. Light is generally placed within the context of energy transfer. The following concepts and abilities are addressed in the New GEMS *Color Analyzers*.

### Physical Science (5–8): Transfer of Energy

- Light interacts with matter by transmission (including refraction), absorption, or scattering (including reflection). To see an object, light from that object—emitted by or scattered from it—must enter the eye.

- The Sun's energy arrives as light with a range of wavelengths, consisting of visible light, infrared, and ultraviolet radiation.

*Benchmarks for Science Literacy* (under 4F—The Physical Setting: Motion—Grades 6–8) adds further specificity on color and vision corresponding to key concepts in this GEMS unit.

- Light from the Sun is made up of a mixture of many different colors of light, even though to the eye the light looks almost white. Other things that give off or reflect light have a different mix of colors.

- Something can be "seen" when light waves emitted or reflected by it enter the eye—just as something can be "heard" when sound waves from it enter the ear.

- Human eyes respond to only a narrow range of wavelengths of electromagnetic radiation—visible light. Differences of wavelength within that range are perceived as differences in color.

### Scientific Inquiry/Abilities Necessary to Do Scientific Inquiry

- Use appropriate tools and techniques to gather, analyze, and interpret data.

- Develop descriptions, explanations, predictions, and models using evidence.

- Think critically and logically to make the relationships between evidence and explanations.

- Recognize and analyze alternative explanations and predictions. Students should develop the ability to listen to and respect the explanations proposed by other students. They should remain open to and acknowledge different ideas and explanations, be able to accept the skepticism of others, and consider alternative explanations.

## Activity-by-Activity Overview

In **Activity 1,** students use the diffraction grating to look at different light sources in the classroom. They discover that while a "white" light source appears to shine in one color, it really gives off many different colors. In contrast, no color can be seen from objects in a dark room, when there is no light.

**Activity 2** has two sessions. In the first session, students use the colored filters on their color analyzers to decode secret messages. Observing these messages with filters is fun, and naturally leads students to discover both which filter works best for which message and some simple rules for creating new secret messages. Having learned that the white light in their classroom is actually a full spectrum of colors, the secret message activity inspires students to wonder what happens when light reflects from the colors of their secret messages, and what changes take place when the light shines through the holes in the color analyzer. The second session follows naturally from their experience decoding secret messages. Students apply what they learned to create their own secret messages. The concepts of color and light may not yet be clear for many students, but their experimentation with colors and filters allows them to test ideas they are forming in the context of an artistically creative activity.

In **Activity 3** the class studies the white light from an overhead projector. Shining the light through a diffraction grating projects a beautiful spectrum of colors on the wall of the classroom. Colored paper apples placed in these projected colors dramatically demonstrates how differently colored objects appear when light is reflected and when it is absorbed. With this experience, along with their explorations in the

earlier activities, students are ready to tackle the question of why objects appear different colors. At the end of the activity, students revisit their initial ideas about light and color, and evaluate how their ideas have changed.

**Activity 4** gives students a needed opportunity to bring together what they've learned in the unit. Students revisit and deepen their understanding of what color filters do and classroom projections help them test their explanations. As in the rest of the unit, strong emphasis is placed on students coming up with their own modifications, and on modifying and deepening their ideas through group discussion. The class discusses the full list of basic concepts that has been posted throughout the unit, and, in the end, return to questions about a red bird in a green cage. Several alternative ways to close the unit are also suggested.

The "Background for the Teacher" section contains information that may be helpful to you in presenting the unit and responding to student questions. It is not meant to be read out loud to your students. While you may wish to convey some of the background information in class, keep in mind the concepts will be most meaningful *after* the students have had an opportunity to experience and reflect on phenomena for themselves.

We hope your students will enjoy these activities and make some discoveries about the objects and phenomena they see every day. The basic concepts they learn can eventually help them answer other questions about our colorful world, such as why sunlight causes black cars to feel warmer than white cars, and why we see rainbows.

Several other GEMS guides make strong and interesting connections to this unit. *More Than Magnifiers* is an exploration of how lenses affect light and how lenses are used in magnifying glasses, cameras, telescopes, and projectors. In *Microscopic Explorations* a variety of activities using hand lenses and microscopes introduce students to the hidden world of the very small. And *Invisible Universe* uses the exciting context of astronomy and a NASA mission to provide middle school students with essential information about and direct experience with the entire electromagnetic spectrum—not just visible light. ■

## Overview

**A** study of fifth graders, *Children's Concepts of Light and Color,* showed that the vast majority think white light is clear or colorless. Students also commonly make distinctions between sunlight, daylight, electric light, and light rays—all of which are regarded as examples of the *same* phenomenon by physicists.

The same study revealed that textbook-based instruction alone has little success in changing student misconceptions about light. Children tend to develop theories based on direct experience, and accepting new theories based on unobservable constructs is difficult.

In this activity, students are introduced to color analyzers, a card with three windows that alter the light that passes through them. In one of the windows is a diffraction grating, with which students gather direct evidence that light which appears white is really made up of different colors. They also discover firsthand that different light sources contain different amounts of various colors.

Students are also introduced to the phrase, "Our eyes are light detectors." This will be a simple theme that carries throughout the unit. Along with more sophisticated concepts about spectra, reflection, and absorption, many students will require reinforcement of the basic idea that our eyes see only the light that comes into them, and that objects themselves, without light, cannot be seen.

*In 1672, Sir Isaac Newton published his theory that sunlight is composed of light of many different colors.*

---

### Learning Objectives for Activity 1

- Provide students with real-life experiences to initiate their investigation of light and color and to deepen their understanding of the color spectrum.

- Deepen student understanding of two basic concepts—also expressed in signs posted in the classroom—that white light is actually a mixture of many colors of light and that our eyes are light detectors.

---

## ■ What You Need

**For a class set of color analyzers:**
- ❑ 1 pair of scissors
- ❑ 1 roll of clear tape
- ❑ about 35  3" x 5" index cards
- ❑ 1  6" x 6" sheet of red filter gel
- ❑ 1  6" x 6" sheet of green filter gel
- ❑ 1  6" x 6" sheet of diffraction grating material
- ❑ *(optional)* 1 paper cutter
- ❑ *(optional)* 1 single-hole paper punch
- ❑ *(optional)* 1 sheet (about 8 ½" x 11") of clear acetate to cover the diffraction grating

**For the class:**
- ❑ 1 lightbulb (60–100 watts)
- ❑ 1 lamp (without a shade)
- ❑ an extension cord, if necessary
- ❑ 2 large pieces of paper (for two signs)
- ❑ masking tape
- ❑ 1 box of colored chalk or a large piece of paper and colored markers
- ❑ 2 or more other light sources such as fluorescent, neon bulbs, or sunlight (see Getting Ready #6)
- ❑ paper to help darken the classroom
- ❑ *(optional)* 1 pair of thin rubber or cotton gloves (for handling diffraction grating)

**For each group of 2–4 students:**
- ❑ 1 set of crayons, colored pencils, or felt-tipped markers with the following colors: red, orange, yellow, green, blue, purple

**For each student:**
- ❑ 1 copy of the **Color Analyzers: Light Through a Diffraction Grating** student sheet (page 18)
- ❑ 1 piece of blank paper
- ❑ 1 color analyzer

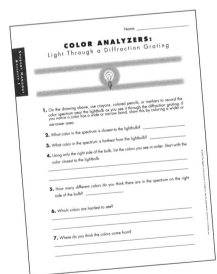

## ■ Getting Ready

**1. Prepare a class set of color analyzers.** A class set of color analyzers is one per student plus a few extras. The materials listed above will make about 35 color analyzers with some filter and grating material left over. Making color analyzers takes an hour or two. Enlisting the help of several students will make this task go

much more quickly. Once made, these analyzers will be used in most of the activities and can be reused year after year.

a. Find a large clear surface on which to work. It should be free from breezes and excessive foot traffic.

b. Cut three diamond-shaped holes, about $\frac{1}{2}$ inch across, in each index card. This can be done by folding the card in half, the long way, and then cutting three V-shaped notches along the fold. Don't cut the notches too deep. Cut the first notch in the middle and then cut one on either side, between the middle and the edges. When all the cards are cut, open and flatten them.

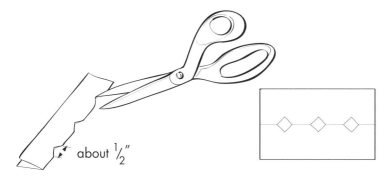

about $\frac{1}{2}''$

c. Cut a 3" x 3" square piece from the red and green filter material. Set both squares aside to use later in the overhead projector demonstration in Activity 4.

d. Use a paper cutter or scissors to cut the remaining red and green filter material into squares big enough to cover the holes in the index cards (about $\frac{3}{4}''$ square). Do the same with the entire piece of diffraction grating material.

e. On each card, place a green filter square over the left hole, a red square over the center hole and a diffraction grating over the right hole. Before adding the diffraction grating, you may choose to sandwich it between two $\frac{3}{4}''$ squares of clear acetate.

f. Tape the filters and the diffraction grating down. You may be able to use one long piece of tape along the top and another along the bottom. Do not let the tape cover the holes in the card.

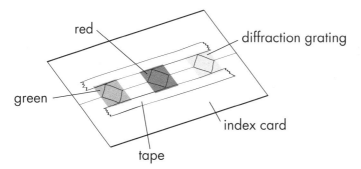

red

diffraction grating

green

index card

tape

2. Make one copy of the **Color Analyzers: Light Through a Diffraction Grating** sheet (page 18) for each student.

3. On the large pieces of paper, make two signs. These (and others made later) will be posted throughout the unit. Keep them handy and post them when you reach the appropriate point in the activity. The phrases for the two signs are:

   • **Our eyes are light detectors.**

   • **White light is a mixture of many colors of light.**

4. Prepare for how you'll darken the room as completely as possible. You'll need to do things like close shades or curtains and use paper to cover any gaps that allow strong sunshine to come in.

5. Set up the lightbulb where it will be visible to all students. Place it high enough so all of the students can see it from their seats. Your goal is to have students see the lightbulb as the dominant light source with no other lights around it. Here are some things to check:

   • If there are places in the room where you cannot block light from coming in, the lightbulb should be placed so that students who are looking at the lightbulb are facing *away* from the intruding light.

   • Make sure that there are no bright reflections of the lightbulb on shiny surfaces that students will see when they are looking at the lightbulb. White boards, computer screens, and other reflective objects can be covered with paper if they reflect brightly.

6. Identify at least two additional sources of light for your students to view through their diffraction gratings after they have viewed the lightbulb. Good sources include a small opening in the window shade where they can see bright sunlight (but not the Sun directly) and fluorescent overhead lights. A variety of lightbulbs can also be purchased that will fit a standard lamp socket, including colored lights and fluorescent lights. A string of colored holiday lights is also interesting to observe.

7. Decide how you'll put students in small groups. Put together the sets of crayons, colored pencils, or markers and have them ready for the group to share. Also have the colored chalk or paper and markers ready for your demonstration of how to color the spectrum on the student sheet.

8. Have a blank piece of paper ready to hand out to each student. They'll use this to write down their initial ideas about light and color.

9. Have the color analyzers ready to hand out to students.

## ■ Initial Student Ideas about Light and Color

1. Tell the class that today they will start a unit about light and color.

2. Say that to start with you'd like to find out what they already have heard about these interesting subjects.

3. Without further discussion about light and color, pass out the blank paper and give students five to ten minutes to write down their answers to the two questions below. Let students know they will not be graded on their answers. They also do not have to know for certain that everything is exactly correct; they can write things they've *heard* about light and color that they think are true. Later in the unit, they'll read these papers again, to see if some of their ideas have changed. Explain that this short writing assignment will also help you assess what they learn, find out how effective the unit is, and see if there are other related topics the class would like to explore. The two questions are:

   • **What do you know about light?**

   • **Why do we see color?**

4. When everyone has had a chance to write at least some thoughts about each question, make sure their names are on their papers and collect them. (You'll use them again in Activity 3.)

*This pre-assessment should help you zero in on misconceptions your students may have about light and color. Later in the unit, students will revisit their own written thoughts to see how their ideas may have changed and debate common misconceptions. Please see the "Background for the Teacher" section for what research shows are common student misconceptions.*

## ■ Introducing the Color Analyzer

1. Tell the class that each student is going to use a tool or instrument called a color analyzer to find out more about light and color. Explain that the color analyzer is a card with three holes or "windows" in it. Instruct the students that when they receive their color analyzers they should hold each window close to one eye and observe how people and objects in the classroom appear different.

2. Distribute the color analyzers. Ask the students to handle them only by the paper part. Allow two or three minutes for students to use the color analyzers to look around the room.

*To regain students' attention after they've been using the color analyzers, have them hold their color analyzers in the air over their heads. This makes it easy to see which students have given you their attention, and it prevents the color analyzers from distracting students while you gain the attention of the remaining students.*

**3.** Have students share some of their observations. Often students will describe how the colors of their clothes or items posted around the room seem to change.

## ■ Introducing the Diffraction Grating

**1.** Tell students that their eyes are "light detectors" and that each of the windows in the color analyzer changes the light that passes through on the way to their eyes.

**2.** Post the "Our eyes are light detectors" sign in the classroom.

**3.** Tell students that they will further explore the effects of the red and the green windows another time. Right now they will be using the window that seems to have no color. Let them know that in that window is something called a *diffraction grating.* Go on to explain that it's a piece of plastic with many tiny ridges in it. Students may be tempted to try to feel the ridges, but ask them not to touch the diffraction grating.

**4.** Turn on the lightbulb, turn off the classroom lights, and darken the room as much as possible.

**5.** Have students look toward the lightbulb with the diffraction grating window held very close to one eye. Then tell them to look at the region around the lightbulb—above and below and to the right and left.

**6.** Most students will immediately notice rainbow colors radiating from the lightbulb. To make sure every student can see them, ask the class to respond to the following questions and note their responses:

- "Raise your hand if you see the colors on the right and left side of the lightbulb."

- "Raise your hand if you see the colors above and below the lightbulb." [Responses to these two questions will vary depending on how the students are holding their color analyzers.]

- "What do you see when you turn the card while looking through the window?" [The colors "orbit" the lightbulb.]

- "What color looks closest to the light?" [Purple or violet.]

- "What color looks farthest, or most separated from the light?" [Red.]

It is not important for your students to understand how a diffraction grating works in order to use one for analyzing light. For most students, the simple explanation provided at the end of this activity is adequate. For teachers who want more information or for those with more advanced students, see the "Background for the Teacher" section on page 52 which describes how both diffraction gratings and prisms work.

7. Circulate and help students who cannot see any colors by giving them the following tips:

  • Hold the color analyzer right next to one eye so that the lightbulb is centered in the hole. When you look through the diffraction grating, look at areas *off to the side of* (or above) the lightbulb.

  • Try moving closer to the light.

8. Some students may notice that the series of colors is repeated once or twice on each side of the lightbulb, as they look farther away from the lightbulb. Seeing these extra bands of color is fine, but not necessary. Be sure that all of the students can see at least one "line of colors" on either side of the bulb before going on.

9. After the initial excitement, explain that the collection of colors is called a color **spectrum.** (The plural of spectrum is **spectra.**)

*If there are light sources in the room other than the lightbulb, students may see distracting colors through the diffraction grating. To help them focus on the light coming from the lightbulb, have them center the bulb in the window and rotate their color analyzers. The band of colors coming from the lightbulb should rotate around the lightbulb; those are the colors students should focus on.*

## ■ Recording the Color Spectrum

1. Give one **Color Analyzers: Light Through a Diffraction Grating** sheet to each student. Hold up one student sheet for the class to see, and explain that the white areas extending from the right and left of the illustrated lightbulb are where they will record the colors they see through the diffraction grating window of the color analyzer. Remind them to rotate the color analyzer so the colors extend to the left and right. This way the spectrum will be oriented the same way as the drawing on the data sheet.

2. Either on a large sheet of white paper or on the board, sketch a lightbulb with guidelines similar to the ones on the data sheet. Without giving away any information about the order of the colors in the spectrum, use markers or colored chalk to demonstrate how to record colors in the white areas.

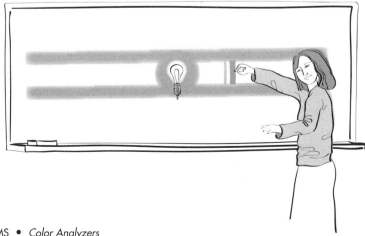

It's possible that some students in your class have the visual problem called "color blindness," which actually means difficulty in distinguishing between certain colors, such as red and green. If you notice a student having difficulty, don't call attention to him or her in class. See "Background for the Teacher" for additional information.

The question of the number of colors in the spectrum is open-ended. In fact, there are an **infinite** number, a gradation of hues that blend continuously across the spectrum. The number of colors you name depends on how you lump together different regions of the color spectrum. Since students were provided with six colored crayons, many students will answer that they see six colors in the spectrum. Some students may be familiar with Isaac Newton's description of the spectrum as containing seven colors: red, orange, yellow, green, blue, indigo, and violet. These students may say that there are seven colors. Some may even blend the colors of their crayons to include indigo in their drawings of the spectrum. Blending colors of crayons requires skill and practice, but can provide a sense of the spectrum's limitless supply of colors. For more information, please see the "Background for the Teacher" section on page 52.

3. Point out that some of the areas of color in the spectrum may be wider than others. If there is a lot of one color, ask students to draw a wide area to represent that color. If there is a small amount of a color, students should draw a narrow area to represent that color. Tell students the goal is to have the colors on the data sheet look, as much as possible, like what they see through the diffraction grating.

4. Say that when they finish coloring the spectrum, students should answer the rest of the questions on the data sheet. Put students in small groups then hand out crayons, colored pencils, or markers for them to share. Have students begin.

## ■ Discussing the Colors that Come from a Lightbulb

1. When students are finished, regain the attention of the class to begin a discussion of their responses on the student sheet.

2. Discuss the drawing and each of the questions on the student sheet, as shown in the guidelines below. Encourage students to describe their observations, even if they are different from what most other students saw. Leave the lightbulb on during the discussion so the students can check their responses.

### Color Analyzers:
### Light Through a Diffraction Grating

1. On the drawing above, use crayons, colored pencils, or markers to record the color spectrum near the lightbulb as you see it through the diffraction grating. If you notice a color has a wide or narrow band, show this by coloring a wider or narrower area. [Most students will have colored in six colors in the spectrum (from the lightbulb outward: purple, blue, green, yellow, orange, and red), but answers will vary.]

2. What color in the spectrum is closest to the lightbulb? [Purple.]

3. What color in the spectrum is farthest from the lightbulb? [Red.]

4. Using only the right side of the bulb, list the colors you see in order. Start with the color closest to the lightbulb. [Varying answers are fine. A common response is purple, blue, green, yellow, orange, red.]

5. How many different colors do you think there are in the spectrum on the right side of the bulb? [Accept all answers and see which are most common.]

6. Which colors are hardest to see? [The most common responses are blue and yellow, but answers may vary.]

7. Where do you think the colors come from? [Students may say the colors come from the light or from the plastic diffraction grating.]

3. Hold a class discussion of the students' ideas about question #7, and investigate each possibility. For example, if students suggest that the colors are coming from the diffraction grating itself, ask what they would see through the diffraction grating if you turned off all of the lights in the room. Turn off the lights. [No colors will be visible through the diffraction grating.] Then turn on the lightbulb so the students can see the light from that source only. This will help the students realize that a light source is necessary to see the colors through the diffraction grating.

4. Help the class conclude that the colors are in the light itself, but it is necessary to have the diffraction grating to see them. Say that *white light is a mixture of colors. The diffraction grating simply separates the colors that are already in the white light.*

5. Post the "White light is a mixture of many colors of light" sign next to the "Our eyes are light detectors" sign.

6. Explain briefly how a diffraction grating works: The plastic has thousands of fine ridges. When light passes through the ridges, most of it goes straight through, so we see the bright light in the center. The tiny ridges cause some of the light to spread out to the left and right. Different colors from the bulb spread out different amounts, forming the spectra that we see to the left and right (red spreads out more; purple spreads out less).

■ **Exploring Light from Different Sources and Summarizing the Activity**

1. Now have students look at fluorescent bulbs, at sunlight coming in the window (but not at the Sun itself), or at a neon light to find out how these lights compare to the lightbulb. Encourage students to discuss their observations. [The colors from a fluorescent bulb appear in the same order as the spectrum from the incandescent lightbulb, but certain parts of the spectrum are dim, while a few narrow bands in the spectrum are very bright.]

2. Say that many people have trouble believing that white light is made up of this spectrum of colors, because white light looks clear

*Students who have experienced how the colors in paint mix may know that, in the case of paint, mixing in more colors makes paint darker and **less** like white. Confirm that this is the case with paint, and point out that mixing colors of light is not the same as mixing colors of paint. The colors in light do not behave in the same way. For more information about this interesting topic, see the discussion of primary colors in "Background for the Teacher."*

*An incandescent lightbulb has a wire in it that is so hot that it glows with all the colors of the spectrum. It is very much like sunshine, which comes from a sun that is so hot that it glows with all the colors of the spectrum. Fluorescent lights are more energy efficient than incandescent lights, but they cannot create all the colors of sunshine evenly. The makers of these bulbs use materials that give off only a few colors of the rainbow, but mixed together they appear white.*

*It may be helpful to ask students if they have ever noticed any difference in the appearance of objects illuminated by fluorescent lights. [Older fluorescent lights were weak in the red part of the spectrum, and some objects illuminated by them were often dull looking. Modern fluorescent lights are much better at creating lifelike color tones.]*

and colorless to our eyes. Let students know that they will get more evidence and learn more in future activities about the colors in white light, how filters work, and how our eyes see colors.

**3.** On the chalkboard, draw an illustration similar to the one on this page. Explain that one of the ways scientists think about light is as a series of waves, similar to water waves. Like water waves, light waves have hills and valleys, called crests and troughs. The distance between the two crests is called the **wavelength.** (The distance between two troughs is also the same, so is also one wavelength.)

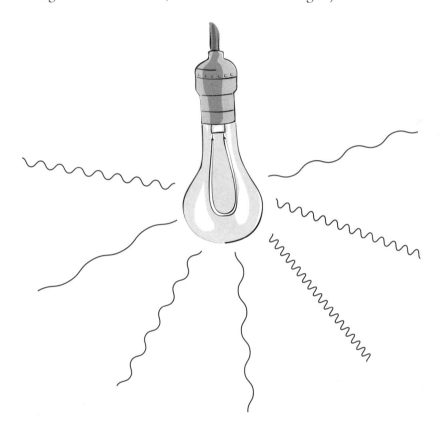

*Only a certain range of wavelengths of light is visible to human eyes, from about 350 nm to 700 nm. The abbreviation nm stands for nanometer, and 1 nanometer is one-billionth $(10^{-9})$ of a meter! Violet light has the shortest wavelength of the colors humans are able to see (about 350 nm). Waves with slightly shorter wavelengths than 350 nm are called ultraviolet light. Red has the longest wavelength (about 700 nm) of visible light. Waves with slightly longer wavelengths are called infrared light. For more on light, wavelength, and the electromagnetic spectrum see "Background for the Teacher," refer to books like those in "Resources," and/or consider presenting the GEMS* Invisible Universe *guide to your class.*

**4.** Point out that light waves have wavelengths that are **millions of times shorter** than water waves. Blue light has a shorter wavelength than red light. Green light has an intermediate wavelength, between that of blue and red. Our eyes interpret different wavelengths of light as different colors.

**5.** Congratulate the students on all their good work. First collect the student sheets, then collect the color analyzers as you tell students that they'll use them more in the next activity.

# ■ Going Further

## 1. Other Spectrum Makers

**Prisms:** Ask students if they can think of other ways to break light into its spectrum. They may have seen it done with prisms, which are usually triangular glass shapes that bend light into different colors in a way similar to how raindrops make rainbows. Isaac Newton used prisms when he started the study of spectroscopy (the science of colors in light).

**CD Rainbows:** Have students bring in some used, junk compact disks. Challenge the students to see the spectrum of the white lightbulb in a darkened room by looking at the light reflected off the compact disk. They will need to experiment by looking at it from different angles. See "Background for the Teacher" for information on how CDs break up light in a way similar to diffraction gratings.

## 2. The Spectra of Other Lights

Look at other lights in your classroom or school through the diffraction grating. A gymnasium or multi-purpose room might be lit by mercury vapor lights or sodium vapor lights. (These are the kind of lights that take several minutes to come on fully after they have been turned on.) Both these types of lights have interesting bright spots in their spectra. Streetlights, neon signs, and television or computer screens are also interesting to observe.

# COLOR ANALYZERS:
## Light Through a Diffraction Grating

**1.** On the drawing above, use crayons, colored pencils, or markers to record the color spectrum near the lightbulb as you see it through the diffraction grating. If you notice a color has a wide or narrow band, show this by coloring a wider or narrower area.

**2.** What color in the spectrum is closest to the lightbulb? _____

**3.** What color in the spectrum is farthest from the lightbulb? _____

**4.** Using only the right side of the bulb, list the colors you see in order. Start with the color closest to the lightbulb.

_____

_____

**5.** How many different colors do you think there are in the spectrum on the right side of the bulb? _____

**6.** Which colors are hardest to see?

_____

_____

**7.** Where do you think the colors come from?

_____

_____

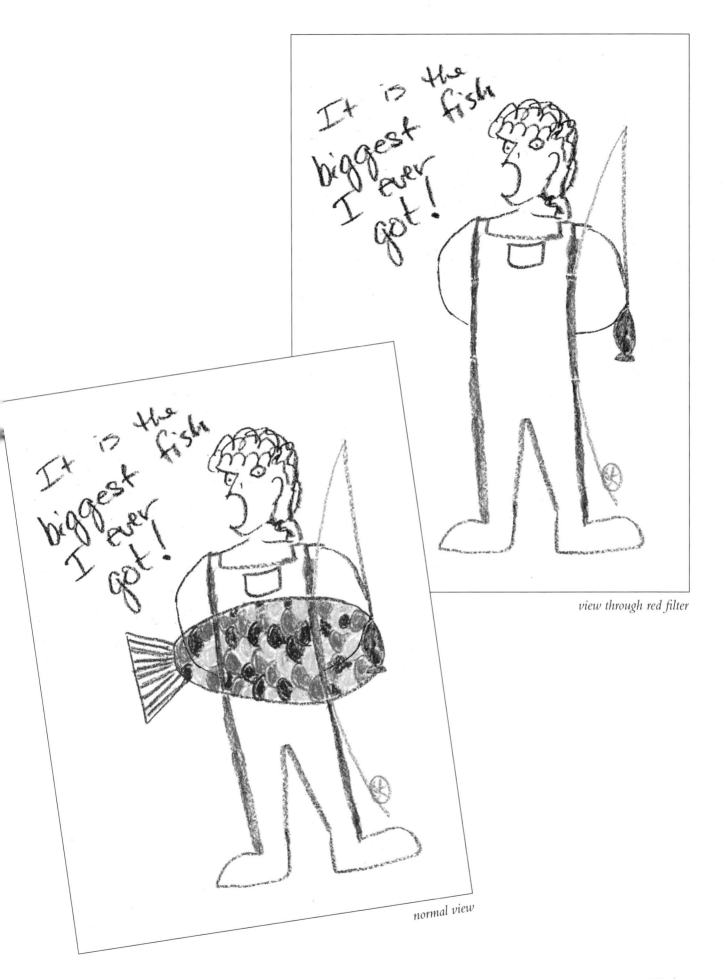

view through red filter

normal view

## Overview

This activity takes two class sessions. In the first, your students discover some mysterious effects of colored light filters. They look at a sample "secret message" with no filter, then through a green filter, then a red filter. The secret message remains a mystery until it is viewed through the red filter, when the message boldly appears. The students then create secret messages using prepared student sheets, and decode them using their color analyzers. Preparing the secret messages and observing the effects of the filters that decode them is fun for students and inspires them to come up with ideas about color and light.

In the second session, the students formulate a rule for making secret messages that can be "decoded" with red filters. After a demonstration of some effective techniques, they apply this rule to invent their own secret messages that will be visible only through the red filter.

The students learn that color filters allow us to see certain colors, but not others. Because of this property, filters enable us to see patterns that our eyes alone can't see. We can thus use filters to decode secret messages, or for scientific purposes such as seeing details on pictures of stars and planets. By the end of this activity, students will have had repeated experiences that help them predict the outcome of viewing a pattern of colors through a filter. Most students, however, will not yet have a good understanding of what a filter actually does to the light that shines through it. Activities 3 and 4 will help complete that understanding so that by the end of the unit students will be better able to describe why the secret messages can be decoded with filters.

---

### Learning Objectives for Activity 2

- Provide students with experiences to help them understand and explain what filters do.

- Introduce the concept of the reflection of light, which is considered in more depth later in the unit.

---

# Session 1: Decoding Secret Messages

## ■ What You Need

**For the class:**
- ❑ the front cover of this guide
- ❑ 8 copies each of the five secret message student sheets (pages 31–35)
- ❑ 1 large piece of paper (for one sign)
- ❑ masking tape
- ❑ *(optional)* an overhead projector (to shine a brighter light on pictures)

**For each group of 2–4 students:**
- ❑ 1 set of crayons★ with the following colors: red, orange, yellow, green, blue, purple

★Colored pencils or felt-tipped markers may be used instead of or in addition to crayons. See remarks in the body of the activity on page 24.

**For each student:**
- ❑ 1 color analyzer (from Activity 1)

## ■ Getting Ready

**1.** Make eight copies each of the five secret message student sheets (pages 31–35).

**2.** On the large piece of paper, make another sign for posting later in this activity. The phrase for the sign is:

- **We detect light that comes directly from light sources; we also detect light that reflects off other objects.**

**3.** Assemble all the remaining materials.

**4.** If you've decided to use it, set up an overhead projector. The bright light of an overhead projector can increase the visibility of pictures that you hold up in front of the class, especially when students are viewing the pictures through the color filters in their color analyzers.

*A drawback to using the overhead projector's light is that students might get the idea that the light is somehow special or necessary to make the secret messages appear.*

# ◼ Introducing the Secret Message

1. Show your students the design on the front cover of this guide (below the title) and tell them there's a secret message hidden in the design. If you're using the overhead projector, hold the guide up in the light shining from it. Ask students to describe what their "light detectors" (their eyes) see. [Colors and shapes.]

2. Remind students that in the last activity they observed a lightbulb that was creating its own light. Ask whether the book is creating its own light. [No.]

3. Tell students that since our eyes are "light detectors" there must be some source of light that lets them see the book and the other objects in the room. Have students identify all the sources of light that are shining on the book (such as light coming in the windows and the regular classroom lights).

4. Ask the students how they think the light that shines on the book gets to our eyes so that we can use our "light detectors" to see it. Accept all answers. Someone will probably say that light bounces off the book. They may even use the word "reflect." Reflection will be covered in more detail in Activity 3, but at this point it is important to state the idea, "We see objects that do not make their own light because they **reflect** the light that shines on them. Reflected light is light that bounces off something."

5. Post the new sign "We detect light that comes directly from light sources; we also detect light that reflects off other objects" with the other signs posted during Activity 1.

6. Review with students that the light that illuminates the classroom is a mixture of many colors—a full spectrum of colors.

# ◼ Decoding the Guide's Cover

1. Pass out the color analyzers. Allow one or two minutes for the students to look around the room through their color analyzers, especially through the diffraction grating so that they can reconfirm the many colors in white light.

2. Regain the attention of the class, hold up the cover of the guide again, and remind students about the secret message. Holding it up in the bright light of an overhead projector makes it much easier to see and makes the effects of the color analyzers more dramatic.

3. Ask everyone to look at the cover of the guide through the green filter. They will still see a nonsensical bunch of colors and shapes.

4. Now have the students look at the cover through the red filter and ask them to describe what they see. They will see the secret message. [LIGHT.]

5. Ask, "Why do you think you see the secret message through the red filter, but not the green?" Accept all answers. Let students know that by the end of this unit they will understand more about how the color analyzers work.

## ■ Making a Secret Message

1. Explain to the students that they will now color secret messages. Suggest that the students put aside their color analyzers until they are finished coloring. Let students know that after they've finished coloring they'll look at their messages through the green and red filters and exchange messages with their neighbors.

2. Put students in small groups to share the crayons. Hand out one secret message sheet to each student, giving each student in the group a different message.

*For your benefit, a color image of each secret message appears on the inside front cover of this guide.*

3. Point out that there are numbers in each of the spaces on the sheets. Each of these numbers corresponds to a different color. The color key appears at the bottom of the sheets. Tell the students not to outline the areas, but to color them evenly.

4. Distribute the crayons and allow the students to start working. Ask them to color quickly because they only have about 15 minutes to complete the secret message.

5. Circulate among the students, answering questions as necessary. Advise students who are coloring very lightly that the secret messages work better with strong colors and suggest that they color more darkly. If students are using colored pencils, they must make a special effort to color each segment of the pattern darkly, evenly, and completely.

## ■ Decoding the Secret Messages

1. When students have finished coloring their secret messages, ask them to look at them through the red and green filters.

2. Have students exchange messages with a neighbor and view their message through the red and green filters.

3. Regain the attention of the class and ask, "Which is the best message decoder—the red or green filter?" [Red—these messages are designed to work with the red filter.]

4. Select a student to hold up his or her secret message. If you are using an overhead projector, have the student hold it in the bright light of the projector.

5. Discuss with the class the appearance of the secret message with and without the red filter.

6. Ask, "When you look through the red filter, which colors look dark and bold and stand out to form the message?" [Green, blue, and purple or violet.] Then ask, "Which colors do not show up well through the red filter, but cover up or *camouflage* the message?" [Red, orange, yellow.]

7. Collect the color analyzers and have students clean up.

*Camouflage simply means concealing or disguising. Most students are familiar with other types of camouflage, such as animal camouflage or military camouflage, which makes something harder to see because it blends in with its surroundings.*

# Session 2: Inventing Secret Messages

## ■ What You Need

### For the class:
- ❑ several pieces of white unlined paper★ (scratch paper is fine)
- ❑ 1 set of crayons with the following colors: red, orange, yellow, green, blue, purple
- ❑ masking tape

★If you prefer to create your demonstration messages on the overhead projector or on a whiteboard instead of paper, you'll need the appropriate colored markers.

### For each group of 2–4 students:
- ❑ several pieces of white unlined paper (scratch paper is fine)
- ❑ 1 set of crayons★★ with the following colors: red, orange, yellow, green, blue, purple

★★As in the first session of this activity, colored pencils or felt-tipped markers may be used.

### For each student:
- ❑ 1 color analyzer (from Activity 1)

## ■ Getting Ready

**1.** Prepare a sample for demonstrating to the students how to make a secret message that will be visible through the red filter. Pick a simple message, like "H I."

   a. On a piece of blank white paper, use crayons to color the left side of the "H" with blue, and the crossbar and right side with green. Write large enough so that the letters can be seen by the whole class. To the right of the "H", leave a space to write in another letter later.

   b. To the right of the space, color the top half of the "I" green and the bottom half blue.

   c. Have red and orange crayons on hand to use in the class demonstration of how to camouflage this message.

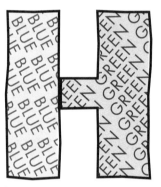 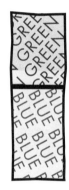

*See the inside front cover for a color version of this message.*

**2.** Prepare a secret message to use at the end of the class session when it is time to clean up. On a white piece of paper write "TCHLAENAKN YUOPU!" starting with a red crayon and alternating using red and green crayons for each letter. Students will read "CLEAN UP!" with the red filter and "THANK YOU" with the green filter. (Although messages made to be read with a green filter do not show up as distinctly as messages made to be read with a red filter, this message will be effective enough.)

**3.** Have the paper, sets of crayons, and color analyzers available and ready to hand out.

## ■ Reviewing Secret Messages

**1.** Ask students the following questions:

- Which color filter did you use to decode the secret messages in the previous session? [Red.]

- Do you remember what colors were used to write the important parts of the message? [Green, blue, and purple or violet.]

- What colors were used to hide or camouflage the message? [Red, orange, and yellow.]

**2.** Use students' answers to make a chart on the board or a piece of chart paper that can be left up for reference during the rest of this class session. Label the colors that show up as "Message Colors" and the colors that seem to fade out when seen through the red filter as "Hiding Colors" or "Camouflage Colors." Your chart should look like this:

| WHEN USING THE RED FILTER | |
|---|---|
| **Message Colors** | **Camouflage Colors** |
| green | red |
| blue | orange |
| purple or violet | yellow |

## ■ Demonstrating Methods for Making Good Secret Messages

**1.** Ask the students if they can suggest a rule that would help them invent secret messages that could be decoded with a red filter. [To create a secret message, use green, blue, and purple. To disguise it, use red, orange, and yellow.]

**2.** Pass out the color analyzers and tell students that you are going to demonstrate a variety of ways to make secret messages using this rule.

**3.** Tell students the first method is very simple and effective. Hold a white piece of paper up against the wall and write "COLOR" on it with green crayon. With a red crayon write the word "LIGHT" right on top of the word "COLOR." (It helps to make this a little more challenging if you do *not* use your most precise handwriting.)

*Samples of successful techniques are shown in color on the inside front cover of this guide.*

Without using a filter, someone would see a hard-to-read jumble of red and green. Through the red filter the word "COLOR" will stand out. Have students look through the red window of their color analyzers to confirm this.

**4.** Point out to students that in this example the hiding colors were **not** simply scribbled on top of the message colors, but that they formed *other letters* that confuse the eyes and make the message more difficult to decode without the filter. Demonstrate that writing the word "COLOR" in green and scribbling completely over it in red does **not** disguise the word very well even though one might think it would. Have students view this through the red window of their color analyzers.

**5.** Show students another, more complex, way to make a secret message. Hold up the sample "H I" message you made earlier and ask the students to read what it says (without the color analyzer). Ask them how the letters will look through the red filter. [Dark.]

**6.** Ask what colors you can use to camouflage this word. [Red, orange, yellow.] Using red, orange, and yellow crayons, first write an "E" between the "H" and "I", then turn the "I" into an "L", and finally add the letter "P" at the end so that now the message looks like it says "HELP." Have students look at the message through the red window of their color analyzers.

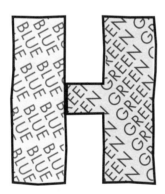

**7.** Show students how using camouflage colors to make additional lines connecting the tops, bottoms, and other parts of the letters in the message can help trick the eye of the viewer and disguise the message. (See the sample on the inside front cover of this guide.) Tell students it's helpful to use at least two different colors for letters, numbers, or lines that are long.

**8.** Say that making secret messages with letters is a good way to start, but drawings can be good secret messages too. On a new piece of white paper, quickly sketch a red bird in a green cage. Ask students to predict what will happen when the drawing is viewed through the red filter. Have them try it. [The cage will be empty.] Keep this drawing for use later in Activity 4.

**9.** Mention that pencils should not be used to sketch designs, because even light pencil lines will show up as part of the message.

## ■ Inventing Secret Messages

**1.** Put students in small groups to share the crayons. Tell the students they'll now invent their own secret messages, either words or pictures, to be decoded with the red filter. Encourage them to be creative. For those who need assistance thinking of ideas, suggest they write their own or their best friend's first name in large letters with green, blue, and purple.

**2.** Tell students that making a good secret message can take practice. They should feel free to experiment and try new strategies even if their message does not come out the way they want the first time. Remind students about the chart of Message Colors and Camouflage Colors that you posted earlier.

**3.** Hand out sheets of paper and sets of crayons and have students begin. Allow the students to keep their color analyzers to check their messages as they work.

**4.** Allow the students about 20 minutes to create their messages. Invite students to post their messages on the wall as they finish them.

**5.** Circulate among the students, answering their questions and encouraging them to experiment and be creative. Remind students who are having trouble that a message with only two colors can be very effective and that it may be a good place to start.

**6.** Just before time is up, show students the secret message you prepared earlier—"TCHLAENAKN YUOPU!" Ask students to look at it with their color analyzers. Students will read "CLEAN UP!" with the red filter and "THANK YOU" with the green filter.

**7.** Have students pack up their crayons, post their finished secret messages, file away any messages that they may want to work on later, and recycle or discard any used paper.

*You may want to caution students not to create "off color" messages.*

*A common mistake is for students to pick up the wrong crayon while hiding a secret message and start to cover their message up with a color that will not disappear. Suggest that after they create their message, and before they start to camouflage it, they put the "message colors" out of reach and keep only the "camouflage colors" available for easy access.*

The students may ask why red filters can decode messages written in blue and green, but green filters are not very useful in decoding messages written in red and orange. For now, it is best just to confirm that the red filters work better than green filters to decode messages, without explaining why. By the end of Activity 4, when students will understand more about the nature of light and how color filters work, the explanation will make more sense.

To help students learn more about how scientists use color filters to study our Sun, check out Seeing the Invisible listed in the Related Curriculum Material section of "Resources" (page 77).

8. Have the class view the posted messages through their color analyzers. Ask for suggestions for improvement if some messages are hard to read through the filter, or are too easy to read without the filter.

9. Conclude by explaining that scientists use color filters for many different purposes. For example, astronomers often use filters to view pictures of stars and planets so they can see details not possible with the eye alone. Demonstrate this by holding up the picture of the star field from the inside back cover of this guide and asking the students to view it through both the green and red filters. Tell them that the picture shows a huge cloud in space, called a nebula that is far bigger than our entire solar system.

10. Ask, "Which filter would you look through to study the stars in this picture?" [Green.] "Which filter would you use to study the cloud?" [Red.]

11. Collect the color analyzers while you compliment the students on their good work.

P - purple or violet

Y - yellow

G - green

R - red

B - blue

O - orange

R - red                    P - purple or violet

B - blue                   Y - yellow

O - orange                 G - green

R - red            P - purple or violet

B - blue           Y - yellow

O - orange         G - green

R – red

B – blue

O – orange

P – purple or violet

Y – yellow

G – green

P - purple or violet

Y - yellow

G – green

R - red

B - blue

O – orange

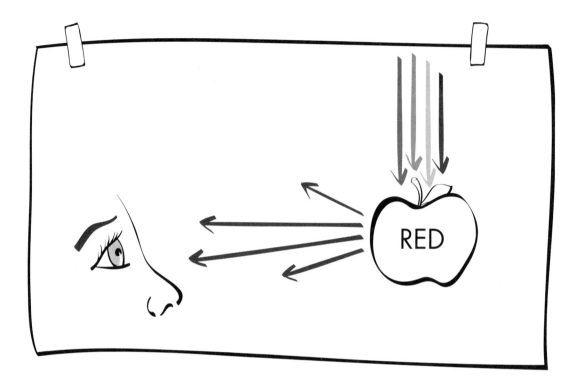

## Overview

Isaac Newton's discovery that sunlight contains many colors led him to be the first to understand that in order to see the colors of objects, they must be illuminated by light. Each object absorbs all colors except for those that are reflected to our eyes. Thus, a red apple absorbs all colors of light except for red, which is reflected from the apple to our eyes. In other words, our eyes detect the light that objects reflect.

Many different research studies show that the majority of students have misconceptions about how we see. Students often think our eyes perceive objects directly, rather than detecting light reflected by those objects. In this activity, you will guide your students in synthesizing what they have observed about light and color in the previous activities, and help them modify their ideas toward a more scientific explanation of why objects appear to be different colors.

---

### Learning Objectives for Activity 3

- Improve and deepen student understanding of how our eyes see color.

- Help overcome persistent misconceptions about light, color, and vision.

- Promote discourse, controversy, and student-originated explanations, helping all students improve their understanding.

---

# ■ What You Need

### For the class:
- ❑ an overhead projector
- ❑ 2 file folders
- ❑ 1 6" x 6" square of diffraction grating material to cover the lens at the top of the overhead projector (see "Getting Ready" #2)
- ❑ 2 large pieces of paper (for two signs)
- ❑ masking tape
- ❑ 1 piece each of red and green construction paper, each at least 3" square
- ❑ 1 piece of white paper (scratch paper is fine)
- ❑ colored markers and a white board or crayons and a large piece of white paper

### For each student:
- ❑ 1 piece of blank paper
- ❑ their writing assignment from Activity 1 (explaining their initial ideas about light and color)

# ■ Getting Ready

1. Use the large pieces of paper to make two more signs. The phrases for the two signs are:

   - **An object may reflect some colors of light and absorb other colors.**

   - **The color of light an object reflects determines the color we see when we look at it.**

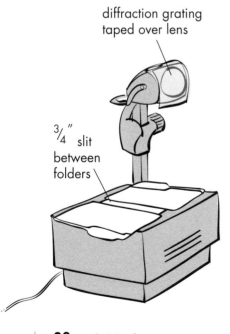

diffraction grating taped over lens

¾" slit between folders

2. Set up an overhead projector and a screen on which to project a large color spectrum. You may use a white wall or white paper taped to the wall if you don't have a screen.

   a. Use two file folders to create a slit about three-quarters of an inch wide in the center of the platform of the overhead projector so that it projects a vertical white line on the screen.

   b. Using a small piece of tape, attach the diffraction grating material over the front of the projection lens so that there is a spectrum projected on each side of the column of white light. You may have to rotate the diffraction grating to properly align the spectrum.

   c. Experiment with the width of the slit to obtain the best projected spectrum. A narrow slit makes the most pure colors, but a wider slit

makes a brighter spectrum. Having the projector farther from the screen helps make the spectrum appear larger. After students see the full spectrum (on both sides of the middle column of light), you'll angle the projector so that one spectrum is centered on the screen.

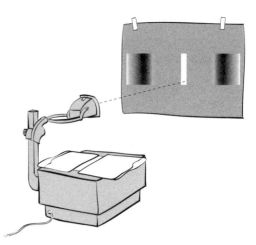

d. Flip the diffraction grating up out of the way so that only the regular white vertical column of light is seen on the screen.

3. From the construction paper, cut out a red and green apple shape, each about three inches across. Have both readily available for the spectrum demonstration, but hidden from students. Also have a piece of white paper ready for the spectrum demonstration.

4. Have either colored markers and a white board or crayons and a large piece of white paper ready for the diagram you'll draw to show light's journey from apple to eye.

5. Have each students' writing assignment (from Activity 1) available and ready to pass out to them at the end of the activity. Also have a blank piece of paper for each student to write on.

## ■ Projecting a Classroom Spectrum

1. Lead the class in a review of some basic concepts about light as summarized on the signs posted during Activities 1 and 2.

   • Our eyes are light detectors.

   • White light is a mixture of many colors of light.

   • We detect light that comes directly from light sources; we also detect light that reflects off other objects.

2. Leaving the room lights on, use the overhead projector arrangement you set up earlier to project the vertical column of white light. (Don't use the diffraction grating yet; leave it flipped out of the way.)

3. Ask, "Where is the light coming from?" [The overhead projector bulb is making the light. The light is bouncing off the screen into our eyes.]

4. Ask, "What color is the light from the projector?" [White.] "What color is the screen that it is shining on?" [Also white.]

5. Ask, "What would happen if we looked at the white light reflecting off the screen with our diffraction gratings?" [We would see all the colors that make up the white light as we did in the first activity with the lightbulb.]

6. Explain that instead of having each student look at the light with their own diffraction grating between the light and their eyes, you will put one big diffraction grating between the projector and the wall.

7. Turn off the room lights so that the room is as dark as possible. Flip the diffraction grating over the lens of the projector and let the class enjoy the large, vivid spectrum for a minute or so.

8. Ask students what they notice. [There is a spectrum on each side of the column of white light. The violet end of each spectrum appears closest to the column of white light, and the red end is farthest away, the same pattern they saw with the lightbulb in Activity 1.]

9. Tell students that for the rest of the activity, it's best to concentrate on just one spectrum. Turn the projector so that just one of the rainbow patterns is projected onto the white screen.

## ■ A Green Apple: Introducing Reflection and Absorption

1. Get out the green paper apple, but do not let students see it in any bright or white light. The room should still be as dark as possible with the only light coming from the projector. Hold the green paper apple in the red part of the projected spectrum. Ask students whether the apple appears to be bright or dark. [It should appear dark.]

2. Move the apple back and forth slowly between the red and the violet ends of the spectrum. Have students notice the change in brightness of the apple.

3. Tell students that as you move the apple back and forth they should raise their hands whenever the apple looks brightest and lower their hands when the apple looks dark again. Tell them that **you** are not going to look at the apple, just at their hands, and that you will try in that way to find the region of the spectrum where the apple looks brightest.

4. Move the apple back and forth through the spectrum again, and after a short time stop with the apple in the spot where you see the most hands in the air. Ask, "What color light is shining on the apple now?" [Green.]

5. By this time students will have ideas about what color the apple is and why it changes brightness when you move it through the spectrum. Ask them to explain their ideas in their own words and allow them to take some time doing so.

*If you think your students would benefit from small group discussions about the color of the apple before taking responses from the whole class, and you can maintain the flow of the demonstration, consider putting your students in small groups.*

6. Hold the green paper apple in the projected column of white light so that the students see its "true color."

7. After comparing the color of the apple with ideas that students had about the apple's color, explain (or confirm) that the green apple **reflects** green light, so that it looks brightest in the green part of the spectrum.

8. Point out that the green apple looks dark in other parts of the spectrum because it does not reflect those colors of light. Explain that light that hits an object and does not bounce off is **absorbed.** Summarize by saying that when light is reflected, an object looks bright. When light is absorbed, an object looks dark.

## ■ Why Does an Apple Look Red?

1. Now show students the red paper apple in the column of white light. Have them predict when the apple will look bright and when it will look dark as you take it for a "walk through the spectrum."

2. As before, as you move the red paper apple back and forth have students raise their hands when the apple looks brightest and lower their hands when it looks dark. After a short time stop with the apple in the spot where you see the most hands in the air. This time they will notice that it looks brightest in the red region of the spectrum.

3. Now, holding up both apples—with one above the other—have students notice that when you move them back and forth between the red part and the green part of the spectrum, the darker apple becomes the brighter one and the brighter apple becomes the darker one.

4. Ask students if they can think of an object that will look bright in *every* part of the spectrum. [A white piece of paper or other white object.] Move a white piece of paper through the spectrum to confirm that a white object reflects all the colors of light.

5. Explain that the red paper apple appears red because *only red light reflects from it and reaches our eyes.* Ask what happens to the other colors of light. [They are *absorbed* by the red ink in the paper—or, in the case of a real red apple, by the red pigments in its skin.]

6. Explain that most objects reflect some colors of light, and absorb other colors of light. Go on to say that the reflected colors are the colors we see when we look at an object.

*The word pigment has not been formally introduced. You may want to just use words like the "red coloring" in an apple's skin instead, or you could briefly define pigment as, in this case, a chemical substance in apple's skin that absorbs all colors except red. See "Background for the Teacher" for more on pigments.*

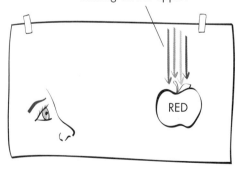

Use many colors, including red, to show white light shining on the apple.

7. Ask students if they would be able to see the color of the paper apples in the dark. Turn off the projector so that the room is very dark. Hold up the red and green apples and have students point to which one is which. Ask if they can see the apples at all. Can they see the colors? Why not? [Our eyes are *light* detectors. There is so little light hitting these apples that the color reflecting off them is not enough to detect.]

8. Leave the overhead projector set up for Activity 4.

## ■ Light's Journey from Apple to Eye—A Quick Review

1. Turn on the classroom lights and organize students into small groups of two to four. With markers on a white board or with crayons on a posted large piece of white paper, draw a red apple at one side of the board/paper and an eye (or a whole face, in profile) at the other side looking toward the apple.

2. Tell students that you are going to make a diagram with their help. Explain that you will ask them questions about how to draw the diagram and they will discuss possible answers quietly in their small groups. When everyone in the group has agreed on the best answer they should all raise their hands.

3. Begin with the first question. Ask, "If I want to draw white light streaming across the board/paper toward the apple, which colors of these markers/crayons should I use to represent the light?"

4. Wait until most, or all of the students have their hands raised. Remind groups who have only some of their members with raised hands to raise hands only if everyone agrees. Accept and discuss all answers.

5. A group will probably suggest using all the colors. With several colors of marker or crayon, including a red one, draw lines coming down from the top of the board/paper to the apple to indicate the many colors in white light shining on the apple.

6. Point out to the students that the apple is red. Ask, "Should I draw the blue or the green light bouncing, or reflecting, off the apple?" Again wait until most of the groups have agreed and accept and discuss their answers. [Blue or green light is absorbed by the apple. You should *not* show it reflecting from the apple.]

**7.** Ask, "Which color should reflect off of the apple?" Their response should be quick. [The red apple reflects only the red light.]

**8.** Using the red marker/crayon, draw red light bouncing off the apple *in all directions,* including into the eye. Confirm with all the groups that the person looking at the apple sees only red light, even though the light that shines on the apple is white.

**9.** Post the two signs you made for this activity near the signs you posted in earlier activities: "An object may reflect some colors of light and absorb other colors" and "The color of light an object reflects determines the color we see when we look at it."

Use only red to show red light reflecting from the apple.

## ■ "Reflecting and Absorbing" (How Have Our Ideas Changed?)

**1.** Make sure all five signs, as well as the diagram the class just made, are in full view of the class.

**2.** Tell students in a few minutes you're going to pass out their papers from the beginning of the unit—with the ideas they had then about light and why we see color. But before that, you'd like them to write down what they now know about why an apple looks red. Pass out a piece of paper to each student.

**3.** Ask them to explain why an apple looks red in their own words, but it's fine to refer to the statements and diagram on the wall as they write. This writing assignment can be used as an assessment of their understanding.

**4.** After about five minutes, collect their writing. Now pass out their papers from Activity 1. Give them a few minutes to look at what they said before, then invite several students to share with the class how their ideas have changed.

**5.** After the class discussion, collect the papers with the students' initial ideas.

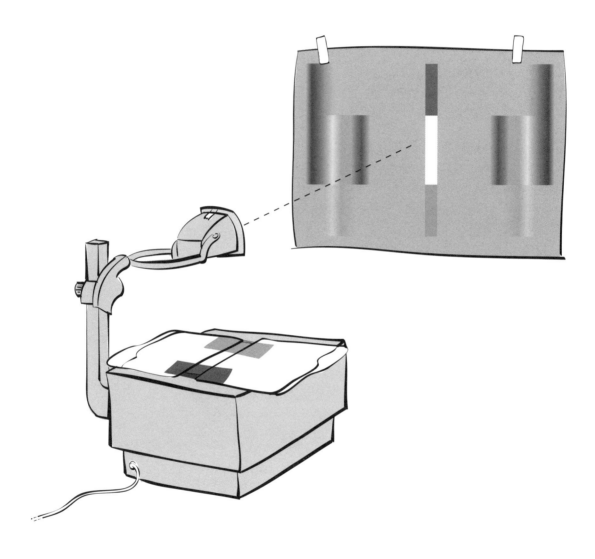

## Overview

**A**ctivity 4 gives students a needed opportunity to bring together what they've learned in the unit. Students revisit and deepen their understanding of what color filters do, and a series of projected challenges helps them further test their explanations. They discuss the full list of basic concepts that has been built throughout the unit, and, in the end, return to questions about a red bird in a green cage. Several alternative ways to end the unit are also suggested.

The goals of this activity are to consolidate students' understanding of the main concepts learned in the unit, as expressed in summary form by the statements posted as the unit proceeds. In particular, this activity unpacks in more detail—and with full encouragement of student-originated explanations—some of the concepts that research shows are often subject to repeated misunderstandings. Many of these concepts come into play through a much closer re-examination of how a filter works. In good scientific fashion, student explanations about both red and green filters are tested on the projector.

---

### Learning Objectives for Activity 4

- Consolidate students' understanding of the main concepts learned in the unit.

- Unpack, in more detail, some of the concepts that research shows are often subject to repeated misunderstandings.

---

## ■ What You Need

**For the class:**
- ❏ the overhead projector, set up as in Activity 3
- ❏ 1 large piece of paper (for one sign)
- ❏ the 3" x 3" piece of red filter gel from Activity 1
- ❏ the 3" x 3" piece of green filter gel from Activity 1
- ❏ the red and green paper apples from Activity 3
- ❏ the drawing of the red bird in the green cage from Activity 2, Session 2

**For each student:**
- ❏ 1 color analyzer (from Activity 1)

## ■ Getting Ready

1. On the large piece of paper, make one more sign. The phrase for the sign is:

   • **A filter lets some colors of light through and blocks other colors. It does not change the color of light.**

2. Check that the overhead projector is set up with the file folders and diffraction grating as it was in Activity 3. Have available the pieces of red and green filter gel that you set aside when you were making the color analyzers in Activity 1. Also have ready the red and green paper apples used in Activity 3.

3. Have the drawing of the red bird in the green cage that you made in Activity 2 ready to show during the summary at the end of this activity.

4. Have the color analyzers ready to hand out to students.

## ■ Another Look at the Paper Apples

1. Show students the red and green paper apples from Activity 3.

2. Ask students a series of questions similar to these:

   • Where does the light that is shining on these paper apples come from? [Windows, classroom lights.]

   • What color is the light? [White, or maybe all the colors.]

- Which sign tells us something about white light? [The one that says "White light is a mixture of many colors of light."]

- What colors of light reflect from the green apple? [Only green.]

- What colors of light reflect from the red apple? [Only red.]

- Which sign says something about colors reflecting from objects? [The one that says "An object may reflect some colors of light and absorb other colors."]

- You told me that only green light reflects from the green apple. If you looked at the green apple through a red filter, would the green light turn red? [No.]

## ■ What Do Color Filters Do to Light?

1. Tell students that what they have discussed about light is crucial to the way we see things but that it is still challenging to explain how the filters in the color analyzers let us make and decode secret messages. Say that to make it clearer you are now going to shine light from the overhead projector through filters.

2. With the diffraction grating flipped away from the lens, remove the file folders from the platform of the overhead projector so the entire glass is exposed. Have the projector squarely facing the screen (not angled as in Activity 3). Turn on the projector so students can see the bright white light on the screen. Then place the pieces of red and green filter material on the projector, next to each other, not overlapping. Students will now see two "blocks" of color—red and green.

3. Turn out the classroom lights and demonstrate that the red and green paper apples change brightness when you move them from the red and green patches of projected light, much the same way they did when you moved them between the red and the green parts of the spectrum in the previous activity.

4. Tell students that now you are going to use the diffraction grating to project the spectrum of light *through the filters,* starting with the red filter. Let students know that they'll work in small groups to discuss their predictions about what they think they'll see.

5. Use the file folders to make a slit on the overhead projector platform to project the column of white light on the screen again, **without using the diffraction grating.** Place the red filter over the top

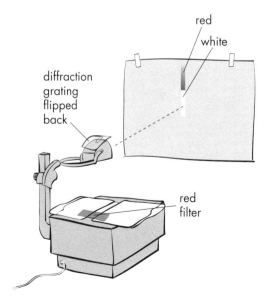

part of the opening between the file folders. Now the top section of the projected column of light will be red instead of white, and the bottom part will still be white.

## ■ Testing Ideas about Red Filters

1. Tell students that in a minute you are going to put the diffraction grating back over the lens so that they will see a spectrum of the entire column of light. Let students know that beside the white column they will see the spectrum of white light, just as they saw it before. Also, beside the red column they will see the spectrum of the light that comes through the red filter.

2. Put the students in small groups. Present the following two ideas and ask the groups to discuss which one, if either, they think makes the most sense.

   • All the colors in the spectrum of filtered light will look red. The filter will change the color of the light.

   • Only the red part of the spectrum will show up. The other colors will be dark. The filter will block the other colors of light.

3. Accept and discuss the predictions of the groups. Encourage them to articulate their reasoning.

4. Now do flip the diffraction grating in place over the lens and angle the projector so that one spectrum is centered on the screen. As in Activity 3, there will be a spectrum of all colors beside the white portion of the column of light. Beside the red portion, the spectrum will appear *without* the violet, blue, and green portions. The red part of the spectrum will still shine strongly.

5. Point out to students that no light actually changed color. The light that was *not red* was blocked—or **absorbed**—by the filter and the red light shone through.

6. Remind students that you have been calling the red and green colored plastic "filters." Ask, "What other kinds of filters have you heard of?" [Fish tank filters, swimming pool filters, air filters, oil filters, coffee filters, water filters, internet filters, etc.]

7. Explain that they are all called filters because a filter is something that lets some things come through and prevents or keeps other things from coming through. A water filter, for example, lets clean water through and keeps the dirt and contamination out. Ask, "Why are the

colored plastic pieces called filters?" [Because they let some colors through and block or **absorb** all the other colors.]

## ■ Testing Ideas about Green Filters

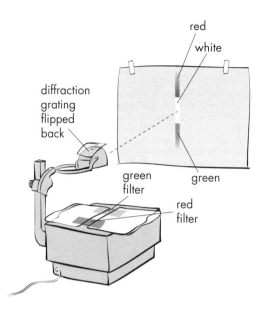

1. Remove or flip up the diffraction grating again so that only the column of red and white light is projected but not its spectrum. Leave the red filter on the projector.

2. Now place a green filter on the projector over the bottom part of the opening between the file folders. Leave a gap between the red and green filters. Now the projected column of light will have a red part at the top, a white part in the middle, and a green part at the bottom.

3. Before using the diffraction grating, say that student groups will discuss their predictions of what the spectrum of the green part of the column of light will look like. Again present to the small groups the two ideas that either the non-green colors might turn green **or** the non-green colors might be blocked out by the filter. Have the small groups discuss the ideas and make their predictions, then have a short class discussion.

4. Flip the diffraction grating in place and let students see the spectrum of the entire column of light—the red part, the white part, and the green part. As before, have the projector angled so that just one spectrum is centered on the screen. Point out to students that, again, none of the parts of the spectrum changed colors. For the green section of the column, some parts of the spectrum became dim and the green part remained bright. (See the color illustration on the inside front cover.)

## ■ Summarizing Understandings

1. Post the last sign next to the others. It says: "A filter lets some colors of light through and blocks other colors. It does not change the color of light."

2. Let students know that now they'll make predictions about what the paper apples will look like through their color analyzers when in white light. Ask questions such as the following to help students reflect on their experience and reinforce the insights they've gained.

   • Would the green paper apple look bright or dark through the red filter? [Dark.]

*If students have been wondering why the secret messages worked better with red filters than they did with the green filters, this may be a good time to point out one of the reasons. In comparing the spectrum of light that comes through the red filter and the green filter, it is easy to see that the red filter is more selective. Even an inexpensive one does a good job of blocking all the colors but red. Most green filters, especially the inexpensive ones, are not as selective about the colors they block. Colors that are not green shine through, though not so brightly.*

- Earlier you told me that only red light reflects from the red apple. If you looked at the red paper apple through a red filter, would it look bright or dark? [Bright.]

- What colors are reflected from the white background? [All the colors.]

- Which colors reflecting from the white background would go through the red filter? [Only red.]

- Which apple is going to look most like the white background when seen through the red filter? [The red one.]

- Which apple is going stand out and look different from the white background when seen through the red filter? [The green one.]

3. Remove the color filters and file folders from atop the overhead projector so that only white light is shining on the screen. Pass out the color analyzers and have students confirm all of their predictions while you hold up the red and green paper apples in the light of the projector.

4. Return again to the example of the red bird in the green cage. Show students the drawing you made in Activity 2. Ask students to predict what will happen when the drawing is viewed through the red filter. Have them try it. [The cage will be empty.]

5. Have a class discussion about why the bird disappears. Encourage students to use the signs you've posted during the unit to help explain their reasoning as they respond to the following questions:

- Why does the green cage look bold and dark through the red filter? [Green light does not go through the red filter; it looks dark.]

- Why does the red bird seem to disappear when you look through the red filter? [Red light goes through the red filter, so the bird looks light. The surrounding paper is white, which reflects all colors, including red. The white paper looks light, like the red bird does, so they both look the same. Because of this the viewer cannot see the bird through the red filter.]

*Note on Alternative Unit Closure: Depending on the level of your class, you may want to modify this suggested closing. It is challenging to explain this, even with all their experiences in the unit. Some teachers prefer, rather than just a large group discussion, to divide the class into small groups to discuss these two questions—with attention to the posted signs—and then reconvene the class to*

consider the responses of the groups. Other teachers prefer to make this a closing writing assignment that serves as an assessment. Another approach is to end the unit before the bird-in-the-cage example. If you do this and have additional time, you may want to consider a "Going Further" activity in which students design one more secret message, trying to utilize all that they have learned.

The following is intended to provide you, the teacher, with information that should be helpful in responding to student questions. It is not meant to be read out loud or duplicated for students.

### What does educational research tell us about student conceptions of light and color?

Research has indicated that the majority of elementary students and some middle-school students who have not received any systematic instruction about light tend to identify light with its source (e.g., light is in the bulb) or its effects (e.g., patch of light). They do not understand light as something that travels from one place to another. As a result, these students have difficulties explaining the direction and formation of shadows, and the reflection of light by objects. Middle-school students often accept the idea that mirrors reflect light but, at least in some situations, reject the idea that ordinary objects reflect light (Guesne, 1985; Ramadas and Driver, 1989). Many elementary- and middle-school students do not believe that their eyes receive light when they look at an object. Students' conceptions of vision vary, for example, from the notion that light fills space ("the room is full of light") and the eye "sees" without anything linking it to the object to the idea that light illuminates surfaces that we can see by the action of our eyes on them (Guesne, 1985).

The conception that the eye sees without anything linking it to the object persists after traditional instruction in optics (Guesne, 1985); however, some fifth graders can understand seeing as "detecting" reflected light after specially designed instruction (Anderson and Smith, 1983). Their study of 227 fifth grade students (*Children's Conceptions of Light and Color,* Anderson and Smith, 1983) found that these misconceptions were not easy to change, but did respond to effective instruction. Almost all students studied shared certain misconceptions about light and its role in vision. Most students believed that their eyes perceived objects directly, rather than detecting light reflected by those objects. About 60% of students accepted that mirrors reflect light, but at least in some situations, rejected the idea that ordinary objects reflect light. Sixty-one percent of students believed color to be something that derives from the object itself, not from the light reflected by those objects. Only two out of 125 students described a green book as reflecting green light. Tests and interviews revealed that the vast majority of students thought that white light is clear or colorless, not a mixture of all the colors of light. Of those who did hold an accurate idea of the nature of white light, only two percent also knew the colors

involved in the mixture. Importantly, Anderson and Smith found that when teachers used conventional textbook-based methods of instruction, only a few students were successful in changing their ideas about light, color, and how we see. In contrast, most students made significant progress in understanding the scientific explanations of light and color when teachers used activity-based materials specifically designed to help students acquire an accurate understanding of these concepts. This GEMS guide is designed to respond to these and other student misconceptions by providing experiences *and* critical student reflection on those experiences to enable improved and lasting student understanding. The content areas involved are large, multidisciplinary, and complex, but units such as *Color Analyzers* build a foundation for students to grapple with these key concepts.

American Association for the Advancement of Science, Project 2061 (1993). *Benchmarks for Science Literacy,* Chapter 15, The Research Base, pp. 338–339, Oxford University Press, New York/Oxford.

Anderson, C., and Smith, E. (1983). *Children's conceptions of light and color: Understanding the concept of unseen rays.* East Lansing: Michigan State University, ERIC No. ED 270 318.

Eaton, J., Anderson, C., and Smith, E. (1983). *Students' misconceptions interfere with learning: Case studies of fifth-grade students.* Research Series Number 128, The Institute for Research on Teaching, Michigan State University, Michigan.

Feher, E., and Meyer, K. R. (1992). Children's concept of color. *Journal of Research in Science Teaching,* 29(5), 505–520.

Fetherstonhaugh, A. R. (1990). Misconceptions and light: A curriculum approach. *Research in Science Education,* 20, 105–113.

Fetherstonhaugh, T., and Treagust, D. F. (1992). Students' understanding of light and its properties: Teaching to engender conceptual change. *Science Education,* 76(6), 653–672.

Guesne, E. (1985). Light. In R. Driver, E. Guesne, and A. Tiberghien (Eds.), *Children's ideas in science* (pp. 10–32). Milton Keynes, UK: Open University Press.

Osborne, Jonathan, Black, P., Smith, M., and Meadows, J. (1991). *LIGHT.* Primary Space Project Research Report, Liverpool University Press.

Ramadas, J., and Driver, R. (1989). *Aspects of secondary students' ideas about light.* Children's Learning in Science Project: Centre for Studies in Science and Mathematics Education, University of Leeds, Leeds, UK.

Sadler, P. (1991). Projecting spectra for classroom investigations. *The Physics Teacher,* 29(7), 423–427.

Shapiro, Bonnie L. (1994). *What children bring to light.* New York: Teachers College Press.

### What is light? What is color?

Light is an electromagnetic wave—that is, a propagation of an electric and magnetic disturbance. There are many kinds of waves (light waves, sound waves, water waves, etc.), and all represent a propagation of a disturbance of some sort. In some respects, scientists describe them all similarly. Waves in water have hills and valleys, called crests and troughs. The distance between two crests (or, equivalently, between two troughs) is called the **wavelength.** Light waves have wavelengths millions of times shorter than water waves.

Our eyes interpret light of different wavelengths as different colors. Blue light has a shorter wavelength than red light. Green light has an intermediate wavelength, between that of blue and red. Since each color of light has a measurable wavelength, scientists can describe a color accurately and unambiguously by stating its wavelength.

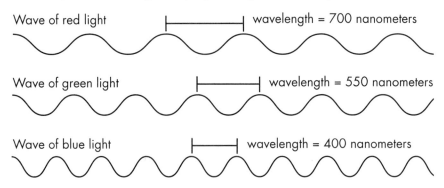

A nanometer is one-billionth of a meter.

### How many colors are in the visible spectrum?

There are as many different colors as there are wavelengths, which is to say that there are an infinite number of colors. No language has names for them all! We can say that there are blue and green in the spectrum, but between them are colors you could call "blue-green," "aqua," "teal," "turquoise," and so on.

*Light can also be thought of as a collection of particles called photons. Physicists combine both particle and wave models of light to understand it as fully as possible. In this brief background section, we will use only the wave model, which is a good model for explaining color. (For a fuller description of the dual nature of light, see the books listed in the "Resources and Literature Connections" section on page 76.)*

Look at all the blue objects around you and you might notice that they are actually very different colors even though they are usually included in the category the English language calls "blue." When Isaac Newton was describing his experiments with light and prisms, indigo was a common dye for fabric. We might call indigo a deep shade of blue, or simply say that it is dark blue, but in the 1600s it was sometimes considered a different color. Newton used indigo in his list of spectral colors—red, orange, yellow, green, blue, indigo, and violet. Many students are taught to remember these colors by making their initials into the name "Roy G. Biv." The Roy G. Biv scheme of spectral colors is not wrong, but it may be no more correct than another scheme with six or eight colors in it.

## What's beyond the visible spectrum?

Only a certain, quite small, range of wavelengths of light is visible to human eyes. Violet light has the shortest wavelength (about 350 nm) of the colors most humans see. Waves with slightly shorter wavelengths are called ultraviolet light. Red has the longest wavelength (about 700 nm) of visible light. Waves with slightly longer wavelengths are called infrared light.

Sunshine is a mixture of ultraviolet, visible, and infrared light. Our eyes only detect light in the "visible" range—that's what visible means! Ultraviolet light is important for many life processes, but too much ultraviolet light can cause sunburn or contribute to skin cancer in humans. Infrared light is not visible to humans, but is easily absorbed by many materials. Objects that absorb light become hotter, and infrared light from the Sun is important in warming the surface of the Earth.

You may have seen ultraviolet and infrared light sources. "Black lights" are ultraviolet lights that are used for special glow-in-the-dark effects. Heat lamps, such as those used to keep food warm, are made to produce mostly infrared light.

Some other animals are sensitive to a different range of wavelengths than humans. Honeybees and some other insects can sense ultraviolet light. Some snakes can sense infrared light. They use it to sense their prey even when it is dark. Electronic "night goggles" can allow humans to "see" (electronically) infrared light.

There are electromagnetic waves with longer wavelengths than infrared light, and there are electromagnetic waves with shorter wavelengths

than ultraviolet. Since these shorter and longer wavelengths are not in the visible range, they are typically described using the general term "radiation," rather than "light."

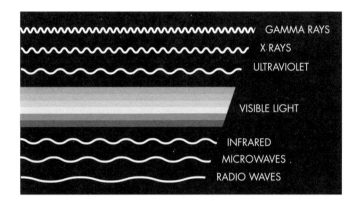

## How do our eyes see/detect color?

The *retina* is a multi-layered membrane that lines the back surface of our eyeballs. Light rays are focused onto the retina by the *cornea* and *lens* at the front of the eyeball. In the retina are two types of photoreceptor or light-sensitive cells, the *rods* and the *cones,* so named because of their shapes. There are more than 130 million of these cells in the human eye, with about 10 to 20 times more rods than cones. Both rods and cones contain chemicals, called *photopigments,* that, when stimulated by light, undergo complex chemical and structural changes. In this way, light signals are transformed into electrical nerve signals that are transmitted through the bipolar and ganglion cells of the retina and then, via the optic nerve, to the brain.

Rod cells do not sense color but only sense lightness and darkness. Rod cells are specialized for vision in dim light and also help us distinguish different shades of dark and light, as well as shape and movement.

Cone cells are used for daylight vision and play the primary role in color vision. The largest number of cone cells is located in the *fovea,* the spot on the retina where the sharpest images are focused, so cone cells also give us sharpness of vision. Cone cells are stimulated only by bright light, which explains why we cannot see color by moonlight. It is believed that there are three types of cone cells, with different light absorption capabilities. The three types of cone cells have slightly different sensitivities to light of different wavelengths. The range of these wavelengths corresponds to the wavelengths we associate with the colors red, green, and blue.

Interestingly, a trichromatic (three-color) theory of color vision was first proposed by the great English physicist Thomas Young in 1802. More recent research has investigated the three types of cone cells and the chemistry involved in the transformation of light to nerve impulse. This research suggests that stimulation of the three types of cone cells by light of particular wavelengths, and the communication of this stimulation through the bipolar and ganglion cells, is interpreted by the brain as color. Research continues on the process within the bipolar and ganglion cells, and on how the information transmitted to and received by the brain allows us to see and classify color.

Individuals are said to be "color-blind" (a misnomer) when a single group of cone cells is missing from the retina. The most common type of this form of color blindness is red–green color blindness, where the cones most receptive to both red light and green light are missing from the eye. Thus, the individual cannot distinguish between red and green. Color blindness of this kind is an inherited condition, with males affected much more frequently than females. There are also individuals with all three cone types, and all three photopigments, but one of the photopigments differs from normal, thereby affecting color vision. There are a number of other more rare conditions that affect color vision.

### What happens to the light absorbed by an object?

Some students are curious to find out what happens to the light that is absorbed by objects. The answer is that light absorbed by an object is turned into increased thermal energy, leading to an increased temperature for the object. For the objects in your classroom, it is difficult to feel this increased temperature, since the light level indoors is fairly low. But outdoors the energy from sunlight is comparatively high. A black (or dark colored) car absorbs most of the light that falls on it, so it heats up quite a bit. By contrast, a white (or light colored) car reflects most of the light that falls on it, so it stays relatively cool. This concept could be illustrated by doing another follow-up activity: Compare white and black paper in sunlight. Feel the temperature difference.

### Why do yellow and orange fade into the white background when viewed through the red filter?

Students notice several times during these activities that red, yellow, and orange fade into the white background when seen through the red filter. The explanation given for why this is true for the color *red* is explicit in the activities.

A possible explanation for why yellow and orange fade is that the red filter allows some yellow and orange light through. This may be true, depending on the redness of the filter, but there is more to it than that.

Most yellow pigments, including pigments in crayons and markers, reflect red and green light as well as yellow. (No wonder yellow pigments look so bright—they reflect a large part of the spectrum.) Since green and red light together look yellow, the mixture of red, green, and yellow light looks just as yellow as it would if it were just yellow light alone. The mark of a yellow crayon, therefore, will appear bright through a green filter or a red filter since the spectrum of reflected light contains both green and red.

Most orange pigments in crayons reflect red and yellow in addition to orange. The orange mark therefore appears bright through a red filter, but not through a green filter.

### How does a diffraction grating work?

The term *diffraction* refers to the spreading of a wave that occurs when the wave encounters an obstacle or passes through an opening. For example, you may have noticed that when ocean waves come in through the opening of a small harbor, they spread out into the arcs shown in the illustration.

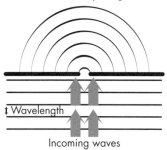

Diffraction of a wave traveling through a narrow opening.

Wavelength

Incoming waves

Now imagine the same situation, but with an island where the harbor opens to the sea so that there are now two openings. The waves spread out from each of these two openings, so that a new circular pattern emerges from each opening. When these two patterns now meet, they **interfere:** Where two wave crests meet, the wave motion is twice as strong as before. By contrast, where a crest from one pattern meets a trough from the other pattern, the two waves cancel, and the water is perfectly still at that spot. This overlap of the two new waves thus results in a pattern called an *interference pattern,* with waves that are strong traveling in some directions and weak traveling in other directions.

A *diffraction grating* is a special piece of plastic that has thousands of very fine parallel lines etched in every inch. When light passes through gaps between these lines, it diffracts, or spreads out just like the water waves described above.

Imagine that only red light passes through the diffraction grating. As the light waves pass through gaps between the lines scratched in the plastic, they spread out. Patterns of light from adjoining gaps cross, and interfere

with each other. Where wave crests from neighboring gaps meet, the light is reinforced and appears very bright. Such reinforcement occurs along lines as shown in the top illustration, and this results in the narrow band of red light that results in the left and right spectra we see.

If blue light passes through a diffraction grating, it also forms an interference pattern. Since the wavelength is different from red light, however, the bright bands appear closer to the center, as shown in the bottom illustration.

Now if white light (which contains many colors) passes through the grating, many interference patterns are formed. The bright regions of each color are slightly offset from the bright regions of the next color—all because the wavelengths of each color of light are slightly different. The result is a spectrum of colors.

Sometimes your students will notice a second spectrum of light some distance from the first. That is where the next series of bright areas in the interference patterns begins.

Any surface with a regular fine pattern in it can create interference patterns and turn white light into a spectrum. An audio or computer CD has a reflective surface with tiny regularly spaced marks. These marks are the recorded data on the disc, but they do a very good job at making interference patterns and spectra. Light reflected off of a soap bubble, or thin layer of oil, also exhibits the same phenomena.

### How does a prism differ from a diffraction grating?
A *prism* is a regularly shaped piece of glass or plastic, or a clear liquid in a bottle with flat sides. When held in a beam of white light, the prism forms a spectrum, much as a diffraction grating does. However, the concept underlying this effect is quite different from that of a diffraction grating.

Imagine that you are looking into a pool of water, and you dip the end of a straight stick into the water. The stick appears to be broken where it enters the water. Draw the stick out and it is straight again! Is it magic? No, it is a phenomenon called *refraction,* or the bending of light when it crosses the boundary between transparent materials, such as air, glass, plastic, or water.

Here's what is happening: A wave of light travels in a straight direction until it encounters a boundary into some other transparent material. If the light hits the boundary head on it will continue in a straight line. But if it

Light with longer wavelength spreads out more.

Light with longer wavelength shines in toward the two openings.

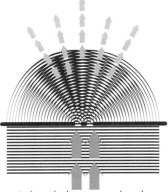

Light with shorter wavelength spreads out less.

Light with shorter wavelength shines in toward the two openings.

*The GEMS teacher's guide* More Than Magnifiers *includes a series of activities on lenses and refraction.*

hits the boundary at an angle, the light will bend (refract) at the boundary. Light of different wavelengths bends (refracts) different amounts.

Hence when light enters a prism, it bends, with the blue light bending more than the red light (see illustration). The different wavelengths of white light are thus separated into different bands. The prism shown is designed so that when the light exits the prism, the blue light is bent further in the same direction as before, thus enhancing the separation. When the waves of light leave the prism they are refracted even farther, thus exaggerating the total refraction. The prism forms a spectrum because some colors of light are bent more than other colors of light.

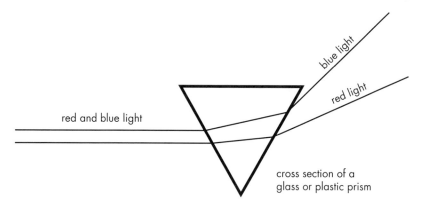

red and blue light

blue light

red light

cross section of a
glass or plastic prism

**What causes a rainbow?**
A rainbow is formed when billions of tiny, clear drops of water are suspended in the air on a rainy day. Each drop acts like a tiny prism (and mirror), refracting (and reflecting) the light from the sun in slightly different directions, depending on the color. Thus, one group of drops will refract the red light from the sun directly toward your eyes, while bending other colors so that they miss you altogether. Light from drops in a nearby patch of the sky will refract the green light in your direction, so that part of the sky appears green, and so on.

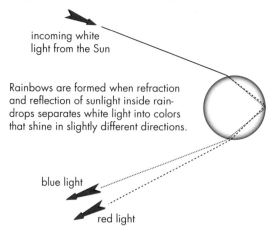

incoming white
light from the Sun

Rainbows are formed when refraction
and reflection of sunlight inside rain-
drops separates white light into colors
that shine in slightly different directions.

blue light

red light

# Primary Colors

In the *Color Analyzers* activities, students view color as coming from a full visible spectrum of light. Another way that the science of color can be approached is to view colors as a combination of primary colors. Students who are doing *Color Analyzers* may be familiar with the ideas of primary colors because they are often part of the curriculum for younger students, although not necessarily in an accurate way. In looking at the colors of light as coming from a spectrum, the *Color Analyzers* curriculum goes to the most fundamental description of the nature of light. This can then help students make accurate sense of the various systems of primary colors.

One reason that students and teachers find the idea of color mixing challenging is that typically there are two systems introduced, one for mixing light and another for mixing pigments. These two systems can seem inconsistent with each other—although as we explain below they are not. In any case, if you're going to explain how a TV screen or computer monitor creates all of the images using only three colors, or how "four-color printing" works, you need to understand the basics of primary colors.

### Why is mixing light different from mixing paint?

Let's first disentangle two distinct phenomena: (A) mixing several different colors of *light* together, perhaps by shining light from red and green flashlights at the same spot; and (B) mixing several different colored *substances* together, such as colored paint, inks, or dyes.

> **A. Mixing Light (Additive Mixing)**
> When mixing colors of *light,* think of starting off with darkness and building color by *adding* primary colors of light. **Red** light, **green** light, and **blue** light—when mixed in the right combinations—can give the appearance of almost any color. Because these colors of light can be used as building blocks for other colors they are called the **primary colors of light.** Color TVs and computer displays rely on these primary colors to make their "full color" images.
>
> Mixing any two primary colors of light gives a **secondary color of light.**
> **Red** and **blue** make **magenta.**
> **Red** and **green** make **yellow.**
> **Blue** and **green** make **cyan** (a greenish shade of blue, like turquoise or aqua).
> **Red** and **green** and **blue** make **white.**
>
> See the color illustration on the inside front cover.

The book Color by Ruth Heller (Putnam & Grosset, New York, 1995) makes a very useful and accessible connection to this unit, helping to clarify the distinction between the behavior of color in the natural world and the four-color process method used in color printing. It is a unique and interactive book, in verse, and it explains how color artwork is reproduced from pictures to the printed page. A four-page acetate printer's proof is bound inside the book. Attractive to younger students, it is just as fascinating and educational for adults!

## B. Mixing Pigments (Subtractive Mixing)

As we've seen in this guide, to understand what color an *object* appears to us, we must think about what happens when we shine light—typically white light—on it. The object will absorb certain colors from that light, as determined by the pigments that are in the object. (The other colors are reflected rather than absorbed, and so determine the color that the object appears.) So when mixing pigments, think of starting with white incident light and then *taking away* color by adding pigments. Mixing pigments is therefore considered "subtractive mixing," since each pigment that is added absorbs another color (or several colors), thus decreasing the amount of light that is reflected from the object.

The **primary colors of pigments are cyan, magenta,** and **yellow.** Printers use these colors, along with black, to give a good rendering of full color—hence the term "four-color printing." Notice that the secondary colors of pigments are the primary colors for light, just as the secondary colors of light are the primary colors for pigments. The two schemes of primary colors fit together very nicely.

Mixing any two primary colors of pigment gives a **secondary color of pigment.**
**Cyan** and **yellow** make **green.**
**Cyan** and **magenta** make **blue.**
**Yellow** and **magenta** make **red.**
**Cyan** and **magenta** and **yellow** make **gray.**

See the color illustration on the inside front cover.

## Primary Color Misconceptions

**Misconception:** Primary color theory is a description of the fundamental nature of light and color.

**Better idea:** Primary color theory is one way that humans organize and apply color theory. The usefulness of primary colors is not because of the nature of light itself, but rather because of the way most human eyes and brains perceive color and light.

**Misconception:** White and black are colors.

**Better idea:** Any light that appears white is a mixture of light from several regions of the spectrum, or a mixture of the entire spectrum. We perceive something as "black" either when no light is incident on the object, or when all of the incident light is absorbed and so no light is reflected.

**Misconception:** Red, green, and blue are the only colors of light and all other colors are combinations of these three.

**Better idea:** In reality, light comes in a full, continuous spectrum of colors. Some combinations of particular colors from that spectrum can be combined to give the appearance of a great range of colors. Red, green, and blue are one such set, and the most commonly used.

To better understand this, let's consider the color yellow. Yellow is a color found in the visible spectrum with a single wavelength, and is seen, for instance, in sunlight dispersed by a rainbow or by a prism. We can also create the perception of the color yellow by mixing red and green (as a TV screen does by illuminating adjacent red and green pixels). **This does not mean that there is no such thing as yellow in the visible spectrum.**

By contrast, some colors that we perceive only exist as mixtures of other colors of light. For instance, there is no single wavelength of light that corresponds to magenta. Instead, we perceive the color "magenta" as a combination of light from the red end and the violet end of the spectrum, similar to the way we perceive "white" as a mixture of all of the colors of the spectrum.

**Misconception:** The color of an object depends on the mixture of pigments in that object.

**Better idea:** The color an object appears depends on the mixture of pigments in that object and on **the spectrum of light that is shining on that object.** This is almost always left out of discussions of primary colors. A pigment that appears one color in full daylight can look different in the light of sunset, under the light of a street lamp, under indoor incandescent lighting, or under a fluorescent light. The perception of an object's color may also vary slightly or greatly depending on the person who is looking at the object, since different people perceive colors differently.

**Misconception:** Once you "get it" about primary colors, it is all very simple.

**Better idea:** Human perception of color is very complex (as we've seen!), involving much more than the notion of three primary colors. There are alternative sets of primary colors for different color applications. Some primary sets use four or even five colors. There are many nuances and unanswered questions about how human eyes see color. There are variations among humans about how we see colors, not to mention variations between humans and other animals. There are always surprises in understanding how this all works. ■

# TEACHER'S OUTLINE

## ACTIVITY 1: THE COLORS IN LIGHT

### ■ Getting Ready

1. Prepare class set of color analyzers.
2. Duplicate one **Color Analyzers: Light Through a Diffraction Grating** sheet for each student.
3. Make two signs: "Our eyes are light detectors" and "White light is a mixture of many colors of light."
4. Prepare to darken room.
5. Set up lightbulb so it's visible to all students.
6. Identify at least two additional sources of light.
7. Decide how to put students in small groups.
8. Assemble all remaining materials.

### ■ Initial Student Ideas about Light and Color

1. Say that today starts a unit about light and color. You'd like to find out what they know or have heard.
2. Pass out paper and give students five to ten minutes to write down answers to:
   - **What do you know about light?**
   - **Why do we see color?**
3. Make sure names are on papers and collect them.

### ■ Introducing the Color Analyzer

1. Say each student will use a color analyzer to find out more about light and color. Explain what it is and how to use it.
2. Distribute color analyzers. Have students use them to look around room then share their observations.

### ■ Introducing the Diffraction Grating

1. Explain that our eyes are "light detectors" and that each window in the color analyzer changes the light that passes through on the way to our eyes.
2. Post the "Our eyes are light detectors" sign.
3. Tell students they'll explore the red and green windows later. Today they'll use the *diffraction grating.* Explain that it's plastic with many tiny ridges.
4. Turn on lightbulb and darken room. Have students look toward bulb through the diffraction grating, being sure to look at the region all around the bulb.
5. Ask questions as in guide, and circulate to help students. Explain that the collection of colors is called a color *spectrum.*

### ■ Recording the Color Spectrum

1. Distribute **Color Analyzers: Light Through a Diffraction Grating** sheets and explain how to record.
2. Sketch lightbulb similar to one on data sheet and demonstrate how to record colors.
3. Say some areas of color may be wider than others. Students should draw areas as wide or narrow to have colors on data sheet represent what they see.

4. Tell students when they finish coloring, they should answer the rest of the questions. Put students in groups, hand out crayons, and have groups begin.

## ■ Discussing the Colors that Come from a Lightbulb

1. When students finish, hold a class discussion, as in guide.
2. When discussing question #7, investigate each possibility to help students realize a light source is necessary to see colors through the diffraction grating.
3. Help class conclude that the colors are in the light itself, though you need the diffraction grating to see them. Say **white light is a mixture of colors. The diffraction grating simply separates the colors that are already in the white light.**
4. Post the "White light is a mixture of many colors of light" sign.
5. Explain briefly how a diffraction grating works.

## ■ Exploring Light from Different Sources and Summarizing the Activity

1. Have students look at fluorescent bulbs, at sunlight, or a neon light to compare to lightbulb. Encourage discussion.
2. Say many people don't think white light is made up of this spectrum of colors, because we see it as clear and colorless. Say that in future activities students will learn more about colors in white light, how filters work, and how our eyes see colors.
3. Draw light waves illustration as in guide. Explain that one way scientists think about light is as a series of waves, with crests and troughs. The distance between two crests is the **wavelength.**
4. Say light waves have wavelengths **millions of times shorter** than water waves. Blue light has a shorter wavelength than red; green has an intermediate wavelength between blue and red. Our eyes interpret different wavelengths of light as different colors.
5. Collect student sheets and color analyzers.

## ACTIVITY 2: LEARNING FROM SECRET MESSAGES

### Session 1: Decoding Secret Messages

## ■ Getting Ready

1. Make eight copies each of the five secret message sheets.
2. Make another sign: "We detect light that comes directly from light sources; we also detect light that reflects off other objects."
3. Assemble all remaining materials.
4. If you've decided to use it, set up an overhead projector.

## ■ Introducing the Secret Message

1. Show students the design on front cover of guide and ask them what their "light detectors" (their eyes) see.
2. Remind students that in the last activity they observed a lightbulb that was creating its own light. Ask if the book is creating its own light.

3. Tell students that since eyes are "light detectors" there must be some source of light that lets them see the book and the other objects. Have them identify all the sources of light shining on the book.
4. Ask how they think the light that shines on the book gets to our eyes so we can use our "light detectors" to see it. Accept all answers. Reflection will be covered more later; for now state the idea: "We see objects that do not make their own light because they **reflect** the light that shines on them. Reflected light is light that bounces off something."
5. Post the "We detect light that comes directly from light sources; we also detect light that reflects off other objects" sign.
6. Review that the light that illuminates the classroom is a mixture of many colors—a full spectrum of colors.

## ■ Decoding the Guide's Cover

1. Pass out color analyzers. Allow a few minutes for students to look around room through them, especially through diffraction grating to reconfirm the many colors in white light.
2. Regain attention of class and hold up cover of the guide again.
3. Ask everyone to look at the cover through the green filter. They will still see a nonsensical bunch of colors and shapes.
4. Now have them look at the cover through the red filter and describe what they see. They see the secret message—LIGHT.
5. Ask why the message can be seen through red filter, but not green. Accept all answers. Tell students by the end of the unit they'll understand more about how the color analyzers work.

## ■ Making a Secret Message

1. Say that they will now color secret messages. Tell them that after they've finished, they'll look at their own and their neighbor's message through the green and red filters.
2. Put students in small groups. Hand out one secret message sheet to each student, giving each in group a different message.
3. Explain that numbers on sheets correspond to different colors. The color key is at the bottom. Say not to outline the areas, but to color them evenly.
4. Distribute crayons and let students start.
5. Circulate, answering questions as necessary.

## ■ Decoding the Secret Messages

1. Ask students to look at their messages through the red and green filters, then exchange messages with a neighbor and view those too.
2. Ask which is the best message decoder—the red or green filter.
3. Select a student to hold up his or her secret message. Discuss appearance of the message with and without red filter.
4. Ask, "When you look through the red filter, which colors look dark and bold and stand out to form the message?" then "Which colors do not show up well through the red filter, but cover up or *camouflage* the message?"
5. Collect the color analyzers and have students clean up.

## Session 2: Inventing Secret Messages

### ■ Getting Ready

1. As detailed in guide, first prepare a sample to demonstrate how to make a secret message that's visible through the red filter, then prepare a secret message to use at end of session.
2. Have paper, crayons, and color analyzers ready to hand out.

### ■ Reviewing Secret Messages

1. Ask the series of questions as in the guide.
2. Use students' answers to make a chart (as shown in guide) of "Message Colors" and "Camouflage Colors." Leave the chart posted for reference.

### ■ Demonstrating Methods for Making Good Secret Messages

1. Ask if students can suggest a rule to help them invent secret messages that can be decoded with a red filter.
2. Pass out color analyzers and say you'll demonstrate several ways to make secret messages using this rule.
3. As described in guide, demonstrate the methods. Have students view each one through the red filter.
4. Say making secret messages with letters is a good start, but drawings can be good secret messages too. Quickly sketch a red bird in a green cage. Ask students to predict what will happen when viewed through the red filter. Have them try it. Keep this drawing for later use.
5. Caution students not to sketch designs, because even light pencil lines will show up.

### ■ Inventing Secret Messages

1. Put students in small groups. Say they'll now invent their own secret messages, either words or pictures, to be decoded with the red filter. Remind students about the chart of Message Colors and Camouflage Colors.
2. Hand out paper and crayons, and have students begin. Students can use color analyzers to check their messages as they work.
3. Allow students about 20 minutes to create messages. Invite them to post their messages when they finish.
4. Circulate, answering questions and encouraging creativity.
5. Just before time is up, display the message you made earlier. Ask students to view it through color analyzers. They'll read "CLEAN UP!" with red filter; "THANK YOU" with green.
6. Have students clean up and post their finished messages.
7. Have class view the posted messages with color analyzers. Ask for suggestions for improvements.
8. Explain that scientists use color filters for many different purposes. For example, astronomers use filters to view pictures of stars and planets to see details not possible with the eye alone. Demonstrate this with picture of star field/nebula from inside back cover of guide. Have students view it through both green and red filters. Explain what picture shows.
9. Ask which filter to use to study the stars and which to use to study the cloud.
10. Collect color analyzers.

# ACTIVITY 3: WHY DOES AN APPLE LOOK RED?

## ■ Getting Ready

1. Make two more signs: "An object may reflect some colors of light and absorb other colors" and "The color of light an object reflects determines the color we see when we look at it."
2. As described in guide, set up an overhead and screen to project a color spectrum.
3. From construction paper, cut out a red and green apple shape. Have both available (but hidden from students) for spectrum demonstration along with a piece of white paper.
4. Have markers and white board or crayons and large white paper ready for diagram you'll draw to show light's journey from apple to eye.
5. Have available each students' writing assignment from Activity 1 and a blank piece of paper.

## ■ Projecting a Classroom Spectrum

1. Review basic concepts about light as summarized on the posted signs.
2. With lights on, use overhead to project vertical column of white light. (Don't use diffraction grating yet.)
3. Ask series of questions: Where is light coming from? What color is light from projector? What color is screen? What would happen if we looked at white light reflecting from screen with diffraction gratings?
4. Explain that instead of having each student look at the light with their own diffraction grating, you'll put one diffraction grating between projector and screen.
5. Darken room. Flip diffraction grating over the lens and let the class enjoy the spectrum.
6. Ask students what they notice.
7. Say for the rest of activity, it's best to concentrate on just one spectrum. Angle the projector so just one rainbow pattern is projected onto screen.

## ■ A Green Apple: Introducing Reflection and Absorption

1. Get out green paper apple, but don't let students see it in any bright or white light. Have room still dark with the only light coming from projector. Hold green paper apple in the red part of the projected spectrum. Ask if apple appears to be bright or dark.
2. Move apple back and forth slowly between red and violet ends of spectrum. Have students notice the change in brightness of the apple.
3. As you move apple, ask students to raise hands when it looks brightest and lower hands when it looks dark. From that you'll find the region of the spectrum where the apple looks brightest.
4. Move apple through spectrum again, and after a short time stop with the apple in the spot where you see the most hands raised. Ask what color light is shining on the apple.
5. Students will have ideas about what color the apple is and why it changes brightness when you move it. Give them time to explain.
6. Hold green paper apple in projected column of white light so students see its "true color."
7. Explain (or confirm) that the green apple **reflects** green light, so it looks brightest in the green part of the spectrum.
8. Say green apple looks dark in other parts of spectrum because it does not reflect those colors. Explain that light that hits an object and does not bounce off is **absorbed.**

9. Summarize by saying that when light is reflected, an object looks bright; when light is absorbed, an object looks dark.

## ■ Why Does an Apple Look Red?

1. Now show students red paper apple in the column of white light. Have them predict when the apple will look bright and dark as you walk it through spectrum.
2. Move red paper apple back and forth and have students raise hands as before. Stop where you see the most hands raised. Apple looks brightest in red region of spectrum.
3. Using both apples, have students notice that when you move them back and forth between red and green parts of spectrum, the darker apple becomes the brighter one and the brighter apple becomes the darker one.
4. Ask if students can think of an object that will look bright in *every* part of the spectrum. Move a white piece of paper through spectrum to confirm that white reflects all the colors of light.
5. Explain that red paper apple appears red because *only red light reflects from it and reaches our eyes.* Ask what happens to the other colors of light.
6. Explain that most objects reflect some colors of light, and absorb others. Go on to say that the reflected colors are the colors we see.
7. Ask if students could see the color of the paper apples in the dark. Turn off projector so room is very dark. Hold up both apples and have students identify which is which. Ask if they can see the apples at all. Can they see the colors? Why not?
8. Leave projector set up for Activity 4.

## ■ Light's Journey from Apple to Eye—A Quick Review

1. Turn on lights and put students in groups. Draw a red apple and an eye/profile as in guide.
2. Tell students you'll make a diagram with their help. Say you will ask questions and group members raise hands when they have an agreed upon response.
3. Begin with first question. Ask, "If I want to draw white light streaming across the paper toward the apple, which colors should I use to represent the light?"
4. Wait until hands are raised. Accept and discuss all answers.
5. A group will probably suggest using all the colors. With several colors, including a red one, draw lines coming down from the top of the board/paper to the apple to indicate the many colors in white light shining on the apple.
6. Point out that the apple is red. Ask whether you should draw the blue or the green light bouncing, or reflecting, off the apple. Wait until most groups have raised hands and accept and discuss their answers.
7. Ask students which color *should* reflect off the apple.
8. Draw red light bouncing off apple *in all directions,* including into the eye. Confirm that the person looking at the apple sees only red light, even though the light that shines on the apple is white.
9. Post the "An object may reflect some colors of light and absorb other colors" and "The color of light an object reflects determines the color we see when we look at it" signs.

## ■ "Reflecting and Absorbing" (How Have Our Ideas Changed?)

1. Make sure all five signs, and the diagram just made, are in full view.

2. Say you're going to pass out papers from Activity 1, but first you'd like them to write down why an apple looks red. Pass out paper to each student.
3. Ask them to explain in their own words, but they can refer to the signs and diagram.
4. After five minutes, collect their writing. Pass out their papers from Activity 1 and ask several students to share how their ideas have changed.
5. After the discussion, collect the papers with the students' initial ideas.

## ACTIVITY 4: PUTTING IT ALL TOGETHER

### ■ Getting Ready
1. Make another sign: "A filter lets some colors of light through and blocks other colors. It does not change the color of light."
2. Check that the overhead projector is set up as it was in Activity 3. Have available the pieces of red and green filter gel, and the red and green paper apples.
3. Have ready the drawing of the red bird in the green cage and the color analyzers.

### ■ Another Look at the Paper Apples
1. Show students the red and green paper apples.
2. Ask a series of questions as in guide.

### ■ What Do Color Filters Do to Light?
1. Say that all they've discussed about light is crucial to the way we see things, but it's still challenging to explain how the filters in the color analyzers let us make and decode secret messages. To clarify, you will shine light from the projector through filters.
2. With the diffraction grating flipped away from the lens, remove the file folders from the platform of the overhead projector so the entire glass is exposed. Have the projector squarely facing the screen. Turn projector on so students see the bright white light. Then place the pieces of red and green filter material on the projector, next to each other, not overlapping.
3. Turn out the classroom lights and demonstrate that the red and green paper apples change brightness when you move them from the red and green patches of projected light—the way they did before when moved between red and green parts of spectrum.
4. Say you'll use the diffraction grating to project the spectrum of light *through the filters,* starting with the red filter. Tell students they'll work in small groups to discuss predictions about what they think they'll see.
5. Use file folders to make a slit on overhead platform to project the column of white light again, **without the diffraction grating.** Place the red filter over the top part of the opening between the file folders. Now top section of projected column of light will be red; bottom part will still be white.

### ■ Testing Ideas about Red Filters
1. Tell students that you are going to put the diffraction grating back over the lens so they'll see a

spectrum of the entire column of light. Say that beside the white column they'll see the spectrum of white light, just as they saw it before. Also, beside the red column they'll see the spectrum of light that comes through the red filter.

2. Put students in groups. Present the following two ideas and ask the groups to discuss which one makes the most sense.
   - All the colors in the spectrum of filtered light will look red. The filter will change the color of the light.
   - Only the red part of the spectrum will show up. The other colors will be dark. The filter will block the other colors of light.

3. Accept and discuss predictions; encourage them to articulate their reasoning.

4. Now flip the diffraction grating over the lens and angle the projector so that one spectrum is centered on screen. There will be a spectrum of all colors beside the white portion of the column of light. Beside the red portion, the spectrum will appear *without* the violet, blue, and green portions. The red part of the spectrum will still shine strongly.

5. Point out that no light actually changed color. The light that was *not red* was blocked—or **absorbed**—by the filter and the red light shone through.

6. Say you have been calling the red and green colored plastic "filters." Ask about other kinds of filters.

7. Explain that these are all called filters because they let some things through and prevent others from coming through. Ask why the colored plastic pieces are called filters.

## ■ Testing Ideas about Green Filters

1. Remove diffraction grating again. Leave red filter on projector.

2. Now place the green filter on projector over bottom part of opening between file folders, leaving a gap between the red and green filters. Now the projected column of light will have a red part at the top, a white part in the middle, and a green part at the bottom.

3. Before using the diffraction grating, say groups will discuss their predictions of what the spectrum of the green part of the column of light will look like. Present to the groups the two ideas that either the non-green colors might turn green **or** the non-green colors might be blocked out by the filter. Have groups discuss the ideas and make their predictions, then have a short class discussion.

4. Flip diffraction grating in place and let students see spectrum of entire column of light. Point out again that none of the parts of the spectrum changed colors. For the green section of the column, some parts of the spectrum became dim and the green part remained bright.

## ■ Summarizing Understandings

1. Post last sign: "A filter lets some colors of light through and blocks other colors. It does not change the color of light."

2. Say students will now make predictions about what the paper apples will look like through color analyzers when in white light. Ask questions as in guide to help students reflect on their experience and reinforce insights they've gained.

3. Remove color filters and file folders from overhead so only white light is shining on screen. Pass out color analyzers and have students confirm their predictions while you hold up the red and green paper apples in the light of the projector.

**4.** Return again to example of red bird in green cage. Show the drawing. Ask students to predict what will happen when drawing is viewed through the red filter. Have them try it.

**5.** Discuss why the bird disappears.

**6.** Consider the alternative ways to close the unit as presented in guide.

# ASSESSMENT SUGGESTIONS

## Anticipated Student Outcomes

**1.** Students gain understanding about light and color as they learn how to make secret messages and why colored light filters work to decode secret messages.

**2.** Students learn light comes from only certain sources, and in order to see something, light must bounce off of the object and come to our eyes.

**3.** Students use a diffraction grating to discover that white light actually has many different colors in it, and black light is the absence of color. They discover the colors come from the light, and not from the plastic diffraction grating.

**4.** Students are able to explain why objects appear to be certain colors.

## Embedded Assessment Activities

**Colors of the Rainbow.** In Activity 1, students use crayons to draw the colors they see through the diffraction grating. The drawings will show the students' perceptions of the order of colors and their orientation. With this information, the teacher can determine whether or not students are looking through the diffraction grating correctly. The discussion at the end of the activity helps the teacher learn about students' understanding of the colors in white light. (Addresses outcome 3)

**Inventing Secret Messages.** In Activity 2, students use colored light filters to decode secret messages and create their own secret messages. These messages provide an opportunity for the teacher to find out if students can properly apply the rules they learned about filtering. For example, red filters transmit red light, but stop all other light. To further assess students' ideas about light and color, the teacher can ask them to explain why their messages "work." (Outcome 1)

**What Happened to the Bird?** In Activity 2, students look at a drawing of a red bird in a green cage. Later, in Activity 4, they are asked to explain why the bird disappears when viewed through a red filter. The students' justifications illustrate the degree to which they have understood how light helps us see things. Their reasoning can also provide evidence of their knowledge about how colored filters function. (Outcomes 1, 2, 3)

**Why Does an Apple Look Red?** The suggested questions at the beginning of Activity 4 are designed to help your students reflect on what they've learned so far, and discover how people perceive color. By listening to their responses, the teacher can determine how well the students have understood that all colors originally come from light sources, and that the reason an apple appears red is because it reflects only red, and absorbs all other colors. (Outcomes 1, 2, 3, 4)

# RESOURCES AND LITERATURE CONNECTIONS

## Sources

### Classroom-Ready Materials Kits

Complete classroom materials kits are available for the GEMS series. To learn more about GEMS Kits—where to buy, what's included, and more—please visit the web at lhsgems. org/gemskits.html or call (510) 642-7771.

## Color Filter Material

In addition to the sources listed below, you may find suitable color filter material at theater supply stores (as spotlight gels) or arts and crafts stores (as cellophane). Before you buy from these sources, be sure to test the effectiveness of the filters by looking at the secret messages on the inside and outside covers of this guide. The messages should be boldly visible through the red filter and look meaningless through the green filter.

Edmund Scientifics
60 Pearce Ave.
Tonawanda, NY 14150
(800) 728-6999
www.scientificsonline.com

Flinn Scientific
P.O. Box 219
Batavia, IL 60510-0219
(800) 452-1261
www.flinnsci.com

Learning Technologies
40 Cameron Ave.
Somerville, MA 02144
(800) 537-8703
www.starlab.com

Rainbow Symphony
6860 Canby Ave., Suite 120
Reseda, CA 91335
(800) 821-5122
www.rainbowsymphony.com

Sargent-Welch
P.O. Box 5229
Buffalo Grove, IL 60089-5229
(800) 727-4368
www.sargentwelch.com

Science Kit & Boreal Laboratories
777 East Park Drive
Tonawanda, NY 14151-5003
(800) 828-7777
www.sciencekit.com

## Diffraction Grating

For the activities in this guide, it is best to use holographic diffraction grating material (*not* ruled diffraction grating) that is single-axis (also called linear) and has between 12,000 and 20,000 lines/inch (between 500 and 750 lines/mm).

Holographic diffraction gratings usually come in squares about six inches to a side, or you can get rolls of several squares. Two squares are plenty for the activities in this guide. You will cut up one square to make color analyzers in Activity 1, and you will use the other square to project a spectrum in your classroom during Activities 3 and 4.

Carolina Biological Supply Company
2700 York Rd.
Burlington, NC 27215-3398
(800) 334-5551
www.carolina.com

Edmund Industrial Optics
101 East Gloucester Pike
Barrington, NJ 08007-1380
(800) 363-1992
www.edmundoptics.com

Edmund Scientifics
60 Pearce Ave.
Tonawanda, NY 14150
(800) 728-6999
www.scientificsonline.com

Flinn Scientific
P.O. Box 219
Batavia, IL 60510-0219
(800) 452-1261
www.flinnsci.com

## Clear Plastic Acetate

Learning Technologies
40 Cameron Ave.
Somerville, MA 02144
(800) 537-8703
www.starlab.com

Rainbow Symphony
6860 Canby Ave., Suite 120
Reseda, CA 91335
(800) 821-5122
www.rainbowsymphony.com

Sargent-Welch
P.O. Box 5229
Buffalo Grove, IL 60089-5229
(800) 727-4368
www.sargentwelch.com

Science Kit & Boreal Laboratories
777 East Park Drive
Tonawanda, NY 14151-5003
(800) 828-7777
www.sciencekit.com

Thin, clear, plastic acetate is an optional material used in the color analyzers to surround and protect the diffraction grating from damage from handling. Acetate is available from the source listed below as well as from art stores.

While overhead projector transparency stock can be used to cover the diffraction gratings, it is important that the material be very clear. Some overhead transparencies are slightly opaque or wavy and this distorts the image students see.

Science Kit & Boreal Laboratories
777 East Park Drive
Tonawanda, NY 14151-5003
(800) 828-7777
www.sciencekit.com

## Related Curriculum Material

**Light, Color, and the Human Eye**
by Doug Sylvester
Rainbow Horizons Publishing Inc.
(2000; 72 pp.)

In this illuminating science unit, students discover the exciting topic of light and the human eye. The integrated lesson plans in this thematic guide are specifically designed to help fourth, fifth and sixth grade elementary teachers. The unit uses student overhead notes to convey much of the knowledge-based material of the unit combined with exciting student activities which relate to the topic of each lesson. The two parts, "Light and Color" and "The Human Eye" can be taught separately or together. Also includes a section on optical illusions sure to keep student interest at its highest.

**Seeing the Invisible**
http://istp.gsfc.nasa.gov/istp/outreach/solar_
observation.pdf

This curriculum, written by NASA educators, helps students discover that the Sun emits light in other wavelengths besides visible light. The optional M&M's® filter activity is useful to illustrate how color and color filters are used to study the Sun. It also helps introduce students to the Solar and Heliospheric Observatory (SOHO), one of NASA's Sun observing projects.

**Teaching Light & Color**
edited by Thomas D. Rossing and Christopher J. Chiaverina
American Association of Physics Teachers, College Park, MD
(2001; 250 pp.)

This collection of scientific papers, articles, and brief excerpts from books is intended to provide teachers with source material for teaching light and color. It also contains references to some 281 books, papers and websites.

## Nonfiction for the Teacher

### Light
**Stop Faking It! Finally Understanding Science So You Can Teach It**
by William C. Robertson
NSTA Press, Arlington, VA
(2003; 106 pp.)

Baffled by the basics of reflection and refraction? Wondering just how the eye works? If you have trouble teaching concepts about light that you don't fully grasp yourself, get help from a book that's both scientifically accurate *and* entertaining. Combining clear explanations, clever drawings, and activities that use easy-to-find materials, this book uses ray, wave, and particle models of light to explain the basics of reflection and refraction, optical instruments, polarization of light, and interference and diffraction. There's also an entire chapter on the workings of the eye. Each chapter ends with a Summary and Applications section that reinforces concepts with everyday examples. Includes a light kit with color gels, polarized film, and diffraction grating.

### Seeing the Light
**Optics in Nature, Photography, Color, Vision, and Holography**
by David Falk, Dieter Brill, and David Stork
John Wiley & Sons, New York, NY
(1986; 480 pp.)

This hefty (and not-inexpensive!) classic makes a valuable addition to any collection of books on light and color. Self-contained chapters function as independent learning units, and the book's experiments use simple equipment. Covers the processes of vision and the eye, atmospheric optical phenomena, color perception and illusions, color in nature and art, and much more.

## Nonfiction for Students

### Color
by Ruth Heller
Putnam & Grosset, New York, NY
(1995; 40 pp.)

Vibrant colors and transparent overlays (included in the book) vividly demonstrate the process of reproducing art for the printed page. Written in verse, with clear illustrations, this book combines simple concepts and complex ideas to explain color printing.

### Light
by David Burnie
Dorling Kindersley, New York, NY
(1992; 64 pp.)

This Eyewitness Science book provides a guide to the origins, principles, and historical study of light.

### The Magic of Color
by Hilda Simon
Lothrop, Lee & Shepard, New York, NY
(1981; 55 pp.)

This book discusses a wide variety of topics related to color, including: after images, primary and complementary colors, and color printing. The explanations are at a fairly high level, but accessible to many middle school students.

### The Magic Wand and Other Bright Experiments on Light and Color
by Paul Doherty, Don Rathjen, and the Exploratorium Teacher Institute
John Wiley & Sons, New York, NY
(1995; 144 pp.)

An educational and entertaining book containing

25 easy-to-perform experiments based on exhibits at San Francisco's Exploratorium. Projects include learning why the sky is blue and the sunset red using a flashlight and a clear box of milky water; exploring reflection by building a kaleidoscope with mirrors, duct tape and cardboard; investigating light waves and refraction by constructing a magnifying lens from a lightbulb and fishbowl filled with water. Through these and the other projects, learn the science behind the mystery of light and color.

## Making Waves: Finding Out About Rhythmic Motion

by Bernie Zubrowski;
illustrated by Roy Doty
Boston Children's Museum Activity Books
Morrow Junior Books/HarperCollins, New York, NY
(1994; 96 pp.)

Full of interesting open-ended experiments to explore waves. Contains background information on the basic properties of waves in liquid and solid materials. Helps students learn about the wave-like behavior of light.

## Mirrors: Finding Out About the Properties of Light

by Bernie Zubrowski;
illustrated by Roy Doty
Boston Children's Museum Activity Books
Morrow Junior Books/HarperCollins, New York, NY
(1992; 96 pp.)

Using mirrors and flashlights, students learn about reflection, refraction, and the way light travels. The activities explore how mirrors work and how they demonstrate the properties of light.

## Optics: Light for A New Age

by Jeff Hecht
Scribner, New York, NY
(1987; 170 pp.)

Describes the wonders of light and optics, exploring such developments as lasers, fiber optics, and holography.

## Shadow Play: Making Pictures with Light and Lenses

by Bernie Zubrowski;
illustrated by Roy Doty
Boston Children's Museum Activity Books
Morrow Junior Books/HarperCollins, New York, NY
(1995; 112 pp.)

Contains more than 50 experiments to help students explore some of the basic properties of light and discover how the study of shadows led to the invention of the camera.

## Fiction for Students

Many of the books listed here are folktales that connect to this guide because they are about colors. Several introduce opportunities to extend the scientific study of light and color to discussions about color in social and cultural contexts. Even though some of these books were written for younger children, your 5th–8th grade students may enjoy them too. You may also want to make connections with books about sunglasses, color blindness, color vision in humans and animals, how certain colors absorb and others reflect light, rainbows, prisms, and different kinds of secret codes similar to the secret messages in this unit.

## The Adventures of Connie and Diego
### Las aventuras de Connie y Diego

by Maria Garcia;
illustrated by Malaquias Montoya
Children's Book Press, San Francisco, CA
(1987; 24 pp.)
Grades: K–5

The twins Connie and Diego are born different than all the other children because they have "colors all over their little bodies." The other children laugh so the twins decide to run away in search of "a place where no one will make fun of us." They encounter a bear, a whale, a bird (who loves their colors), and a tiger. They learn that although their surface appearance is different from that of other children, they are human beings, no matter what color they may be. This strong anti-racist message, while designed for younger students, becomes a lesson for people of all ages (and colors). The English and Spanish verse appear together on each page.

## Colors

by Pascale de Bourgoing and Gallimard Jeunesse;
illustrated by P.M. Valet and Sylvaine Perols
Cartwheel/Scholastic, New York, NY
(1991; 20 pp.)
Grades: Preschool–2

With this book you mix the colors of the rainbow
by using the transparent color overlays and vibrant
illustrations of animals, flowers, food, and more.
Although designed for early grades, the hands-
on pages of this book create several "discovery"
experiments that could be of interest to older students
as well.

## Hailstones and Halibut Bones

### Adventures in Color

by Mary O'Neill;
illustrated by John Wallner
Doubleday, New York, NY
(1989; 64 pp.)
Grades: All

Originally published in 1961, this modern children's
classic contains twelve two-page poems of impressions
of various colors. The perceptions go far beyond visual
descriptions, painting a full spectrum of images. Many
teachers have highly recommended these poems as an
excellent literary accompaniment to *Color Analyzers.*

## How the Birds Changed Their Feathers

retold and illustrated by Joanna Troughton
Peter Bedrick Books, New York, NY
(1986; 32 pp.)
Grades: K–4

This South American Indian tale tells how all birds
used to be entirely white and then came to have
different colors. When the cormorant kills the huge
Rainbow Snake, the people skin it and jokingly
challenge the bird to carry the skin if he wants to
keep it. All the birds join together to carry it through
the air and each bird keeps the part of the skin it
has carried and its feathers become that color. The
cormorant carries the head and becomes mostly black.
This book is out of print, but can be found in many
public libraries.

## The Legend of the Indian Paintbrush

retold and illustrated by Tomie dePaola
G.P. Putnam's Sons, New York, NY
(1988; 40 pp.)
Grades: K–4

After a Dream Vision, the Plains Indian boy Little
Gopher is inspired to paint pictures as pure as the
colors in the evening sky. He gathers flowers and
berries to make paints but can't capture the colors of
the sunset. After another vision, he goes to a hilltop
where he finds brushes filled with paint, which he
uses and leaves on the hill. The next day, and now
every spring, the hills and meadows are ablaze with
the bright color of the Indian Paintbrush.

## The River That Gave Gifts, an Afro-American Story

written and illustrated by Margo Humphrey
Children's Book Press, San Francisco, CA
(1987; 24 pp.)
Grades: K–5

Four children in an African village make gifts for wise
old Neema while she still has partial vision. Yanava,
who is not good at making things, does not know
what to give, and seeks inspiration from the river.
As she washes her hands in the river, rays of light fly
off her fingers, changing into colors and forming a
rainbow. After all the other gifts are presented, she
rubs her hands in the jar of river water giving a
rainbow and the gift of sight to Neema. In addition
to the themes of respect for elders and the validity
of different kinds of achievement, the color theme
evolves into evoking symbolism of each color in the
rainbow. The book could be used as the start of a
comparison of the scientific view of colors with the
ways color is viewed and used in different cultures
and art. This book could also help prompt an open-
ended discussion about the relationship of light to
color.

## Video

### Exploring Light and Color
United Learning/A division of Discovery Education (1993; 28 minutes)

This video, for grades 5–8, explores light and color through experimentation and observation. Topics include the electromagnetic spectrum, the sources of light, the properties of light, reflection, refraction, lenses, and how human and animal eyes work. A pdf of a teacher's guide is available online. Learn more at www.unitedlearning.com or call (800) 323-9084 to order.

## Magazine Article

"Projecting Spectra for Classroom Investigations," Philip M. Sadler, *The Physics Teacher,* October 1991, 29(7), 423–427.

## Internet Sites

### The Science of Light
www.learner.org/teacherslab/science/light/

This website, for grades 5–8, is part of the Teachers' Lab of the Annenberg/CPB Channel Project. It gives online simulations and hands-on activities to help students learn about light as it relates to color, shadows, and perspective.

### How Stuff Works
www.howstuffworks.com

Provides clear explanations about how things around us work. The following are very useful for this guide.

How Light Works
http://science.howstuffworks.com/light.htm/printable

How Vision Works
http://science.howstuffworks.com/eye.htm/printable

How Rainbows Work
http://science.howstuffworks.com/rainbow.htm/printable

Why do CDs reflect rainbow colors?
http://science.howstuffworks.com/question52.htm

### Science Made Simple
www.sciencemadesimple.com/sky_blue.html#PROJECTS

This explanation of why the sky is blue includes a discussion of light waves and the colors of light. Also included are simple projects for splitting light into a spectrum, creating the sky in a jar, and mixing colors.

### Fact Monster, from Information Please
www.factmonster.com/ce6/sci/A0812936.html

An encyclopedia article on color, which covers topics such as the visible spectrum, apparent colors of objects, and properties of colors.

# REVIEWERS

**W**e warmly thank the following educators who reviewed, tested, or coordinated the trial tests in manuscript or draft form. Their critical comments and recommendations, based on classroom presentation of these activities nationwide, contributed significantly to this GEMS publication. (The participation of these educators in the review process does not necessarily imply endorsement of the GEMS program or responsibility for statements or views expressed.) Classroom testing is a recognized and invaluable hallmark of GEMS curriculum development; feedback is carefully recorded and integrated as appropriate into the publications. WE THANK THEM ALL! ■

## ARIZONA

**Sunset Elementary School, Glendale**
Phyllis Shapiro

**Cholla Junior High School, Phoenix**
Brenda Pierce
Leonard Smith

**Desert Foothills Junior High School, Phoenix**
Nancy M. Bush
George Casner
Joseph Farrier
E. M. Heward
Stephen H. Kleinz

**Desert View Elementary School, Phoenix**
Walter C. Hart

**Lakeview Elementary School, Phoenix**
Sandra Jean Caldwell

**Lookout Mountain Elementary School, Phoenix**
Carole Dunn

**Manzanita Elementary School, Phoenix**
Sandra Stanley

**Maryland Elementary School, Phoenix**
David N. Smith

**Moon Mountain Elementary School, Phoenix**
Karen Lee

**Mountain Sky Junior High School, Phoenix**
Flo-Ann Barwick Campbell
C. R. Rogers

**Mountain View Elementary School, Phoenix**
Roberta Vest

**Royal Palm Junior High School, Phoenix**
Robert E. Foster, III
Nancy Oliveri

**Shaw Butte Elementary School, Phoenix**
Cheri Balkenbush
Debbie Baratko

**Sunnyslope Elementary School, Phoenix**
Don Diller
Susan Jean Parchert

**Washington School District, Phoenix**
Richard Clark★

## CALIFORNIA

**Columbus Intermediate School, Berkeley**
Dawn Fairbanks
Jose Franco
Ann Gilbert
Karen E. Gordon
Chiyomi Masuda
Jeannie Osuna-MacIsaac
Judy Suessmeier
Phoebe A. Tanner
Carolyn Willard★

**University of California Gifted Program**
Marc Tatar

**Willard Junior High School, Berkeley**
Vana Lee James

**Montera Junior High School, Oakland**
Richard Adams★
Stanley Fukunaga
Barbara Nagel

**Sleepy Hollow Elementary School, Orinda**
Margaret Lacrampe
Lin Morehouse★

**Piedmont High School, Piedmont**
George J. Kodros
Jackson Lay★

**Cave Elementary School, Vallejo**
Dayle Kerstad★
Neil Nelson
Tina L. Nievelt
Geraldine Piglowski
James Salak
Bonnie Square

**Dan Mini Elementary School, Vallejo**
Gerald Bettman
James A. Coley★
Jane Erni

**Pennycook Elementary School, Vallejo**
Lee Cockrum★
Deloris Parker Doster
Kathy Nachbaur Mans
Sandra Rhodes
Aldean Sharp
Robert L. Wood

**ILLINOIS**

**Waubonsie Valley High School, Aurora**
Kurt K. Engel
Thomas G. Martinez
Mark Pennington
Sher Renken★
Michael Terronez

**Thayer J. Hill Junior High School, Naperville**
Sue Atac
Miriam Bieritz
Betty J. Cornell
Athena Digrindakis
Alice W. Dube
Anne Hall
Linda Holdorf
Mardie Krumlauf
Lon Lademann
Mary Lou Lipscomb
Bernadine Lynch
Anne M. Martin
Elizabeth R. Martinez
Judith Mathison
Joan Maute
Peggy E. McCall
Judy Ronaldson

**KENTUCKY**

**Johnson Middle School, Louisville**
Martha Ash
Pamela Bayr
Pam Boykin
John Dyer
Mildretta Hinkle
Peggy Madry
Steve Reeves

**Knight Middle School, Louisville**
Jennifer L. Carson
Susan M. Freepartner
Jacqueline Mayes
Donna J. Stevenson

**Museum of History and Science, Louisville**
Deborah M. Hornback
Amy S. Lowen★
Dr. William McLean Sudduth★

**Newburg Middle School, Louisville**
Sue M. Brown
Nancy Hottman★
Brenda W. Logan
Patricia A. Sauer
Janet W. Varon

**Rangeland Elementary School, Louisville**
Judy Allin
April Bond
Mary Anne Davis
Barbara Hockenbury
Carol Trussell

**Robert Frost Middle School, Louisville**
Lindagarde Dalton
Tom B. Davidson
Tracey Ferdinand
Rebecca S. Rhodes
Nancy Weber

**Stuart Middle School, Louisville**
Jane L. Finan
Patricia C. Futch
Nancy L. Hack
Debbie Ostwalt
Gil Polston

**MICHIGAN**

**Bellevue Middle School, Bellevue**
Stanley L. Guzy
Sandy Lellis

**Lake Michigan Catholic Elementary School, Benton Harbor**
Laura Borlik
Joan A. Rybarczyk

**F. C. Reed Middle School, Bridgeman**
Ronald Collins
Richard Fodor
Betty Meyerink

**Buchanan Middle School, Buchanan**
Rhea Fitzgerald Noble
Robert Underly

**Centreville Junior High School, Centreville**
Sandra A. Burnett

**Comstock Northeast Middle School, Comstock**
Colleen Cole
Karen J. Hileski

**Delton-Kellogg Middle School, Delton**
Sharon Christensen★

**Gull Lake Middle School, Hickory Corners**
Gary Denton
Stirling Fenner

**The Gagie School, Kalamazoo**
Beth Covey
Dr. Alonzo Hannaford
Barbara Hannaford

**St. Monica Elementary School, Kalamazoo**
John O'Toole

**Western Michigan University, Kalamazoo**
Dr. Phillip T. Larsen★

**Lake Center Elementary School, Portage**
Iola Dunsmore
Suzanne Lahti

**Portage North Middle School, Portage**
John D. Baker
Daniel French

**St. Monica Elementary School, Portage**
Margaret Erich

**NEW YORK**

**Albert Leonard Junior High School, New Rochelle**
Frank Capuzelo
Frank Faraone
Seymour Golden
David Selleck

**Barnard School, New Rochelle**
Richard Golden★

**City School District of New Rochelle, New Rochelle**
Dr. John V. Pozzi★

**Columbus Elementary School, New Rochelle**
Lester Hallerman
Cindy Klein

**George M. Davis Elementary School, New Rochelle**
Robert Nebens
Charles Yochim

**Isaac E. Young Junior High School, New Rochelle**
Michael Colasuonno
Vincent Iacovelli
Bruce Zeller

**Trinity Elementary School, New Rochelle**
Robert Broderick

**Ward Elementary School, New Rochelle**
Eileen Paolicelli
John Russo

**Webster Magnet Elementary School, New Rochelle**
Helene Berman
Antoinette DiGuglielmo
Donna MacCrae
Bruce Seiden

**Heathcote Elementary School, Scarsdale**
Steven Frantz

**Scarsdale Junior High School, Scarsdale**
Linda Dixon

★Trial test coordinators

# GEMS GUIDES

University of California, Berkeley
**GEMS**
Lawrence Hall of Science # 5200
Berkeley, CA 94720-5200

(510) 642-7771    fax: (510) 643-0309

gems@berkeley.edu

www.lhsgems.org

*Please contact GEMS for a catalog and ordering information.*
— *GEMS student data sheets are available in Spanish* —

# Great Explorations in Math and Science (GEMS) Program

**T**he Lawrence Hall of Science (LHS) is a public science center on the University of California at Berkeley campus. LHS offers a full program of activities for the public, including workshops and classes, exhibits, films, lectures, and special events. LHS is also a center for teacher education and curriculum research and development.

Over the years, LHS staff has developed a multitude of activities, assembly programs, classes, and interactive exhibits. These programs have proven immensely successful at the Hall and should be useful to schools, other science centers, museums, and community groups. A number of these guided-discovery activities have been published under the Great Explorations in Math and Science (GEMS) title, after an extensive refinement and adaptation process that includes classroom testing of trial versions and modifications to ensure the use of easy-to-obtain materials. Carefully written and edited step-by-step instructions and background information allow presentation by teachers without special background in mathematics or science.

**Thanks for your interest in GEMS!**

## COMMENTS WELCOME !

Great Explorations in Math and Science (GEMS) is an ongoing curriculum development program. GEMS guides are periodically revised to incorporate teacher comments and new approaches. We welcome your suggestions, criticisms, and helpful hints, and any anecdotes about your experience presenting GEMS activities. Your suggestions will be reviewed each time a GEMS guide is revised.

# GEMS Supports National Standards in Science and Mathematics

**GEMS**® guides and pedagogical handbooks can serve as a strong support to the *National Science Education Standards* and other leading benchmarks, guidelines, and frameworks, as well as the curriculum standards of the National Council of Teachers of Mathematics (NCTM). Two GEMS handbooks, *The Rainbow of Mathematics* and *The Architecture of Reform*, provide detailed information on how GEMS guides contribute to these national efforts to achieve excellence and provide high-quality science and mathematics experiences for all students.

GEMS activities put into effective practice the inquiry-based approach called for in these documents. GEMS units can be closely correlated to the major areas of content and process knowledge and skills outlined by leading documents. GEMS guides that focus on mathematics and the many guides that integrate science and math provide excellent opportunities for students to explore the major mathematics strands articulated by the NCTM and leading math educators.

The title page of a GEMS guide highlights opportunities for student learning that derive from the activities in the guide. These teaching opportunities include skills, concepts, themes, mathematics strands, and nature of science categories. Themes are seen as key recurring ideas that cut across all the disciplines. In the *National Science Education Standards* these are called "unifying concepts and processes." By listing the themes and strands that run through a particular GEMS unit on the title page, we hope to assist you in seeing where the unit fits into the "big picture," how it connects to other GEMS units, and how it can be combined within a curriculum that supports national recommendations in science and mathematics.

 **GEMS** K I T S®

For information on GEMS Kits, visit the web at **lhsgems.org/gemskits.html** or contact GEMS.

For more information and a free catalog, please contact GEMS.

University of California, Berkeley
GEMS
Lawrence Hall of Science #5200
Berkeley, CA 94720-5200
(510) 642-7771
gems@berkeley.edu